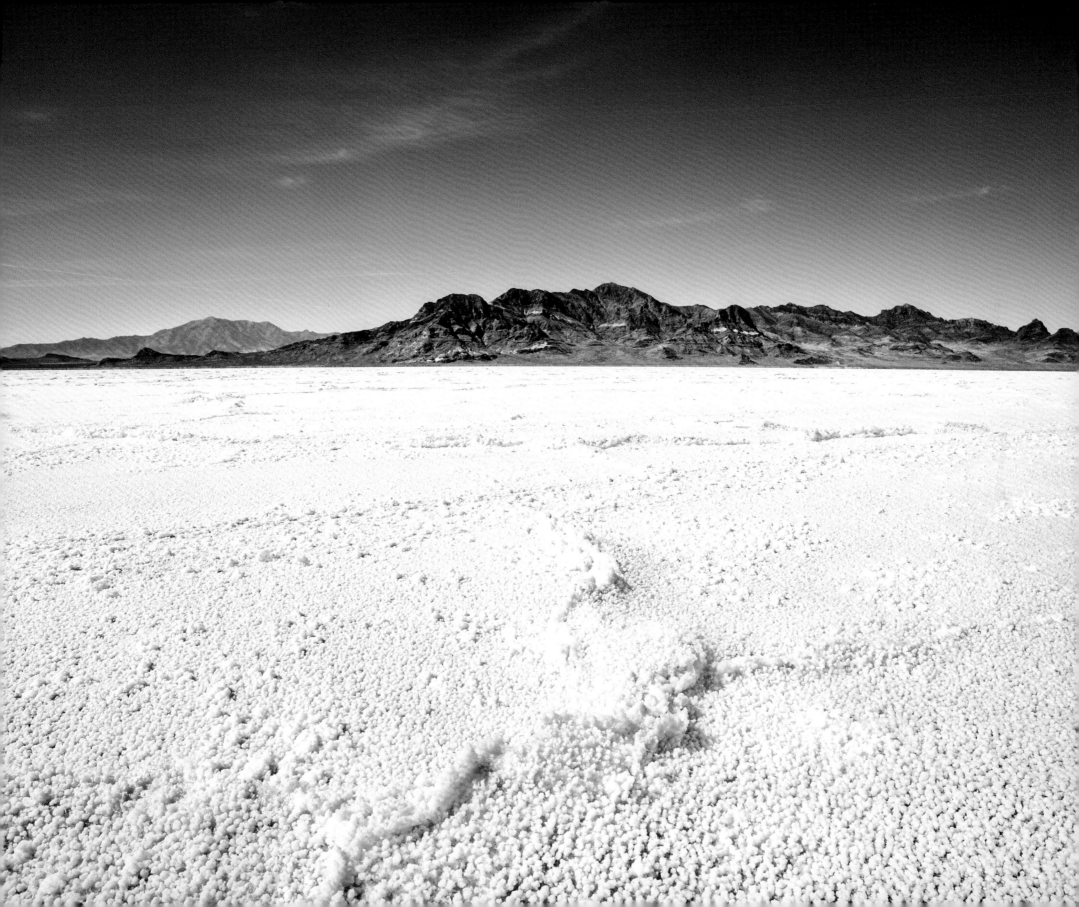

KEHRER

Alexandra Lier

THE WORLD'S FASTEST PLACE

Bonneville Land Speed Racing

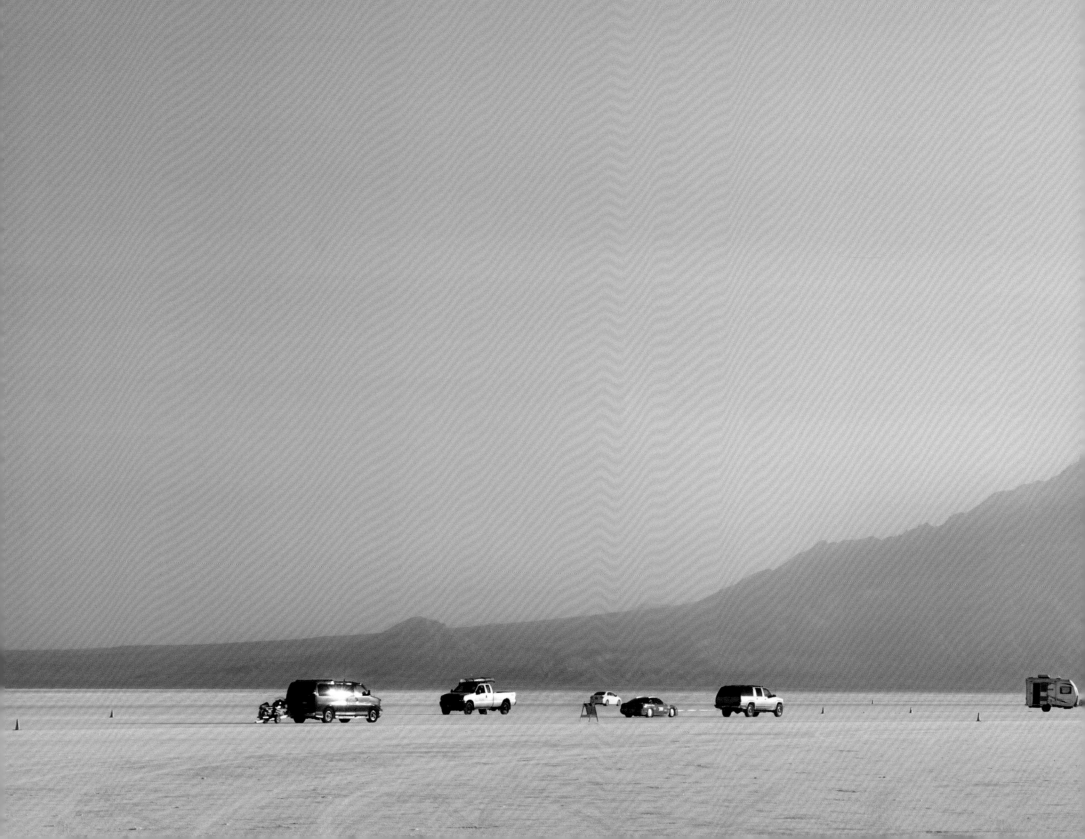

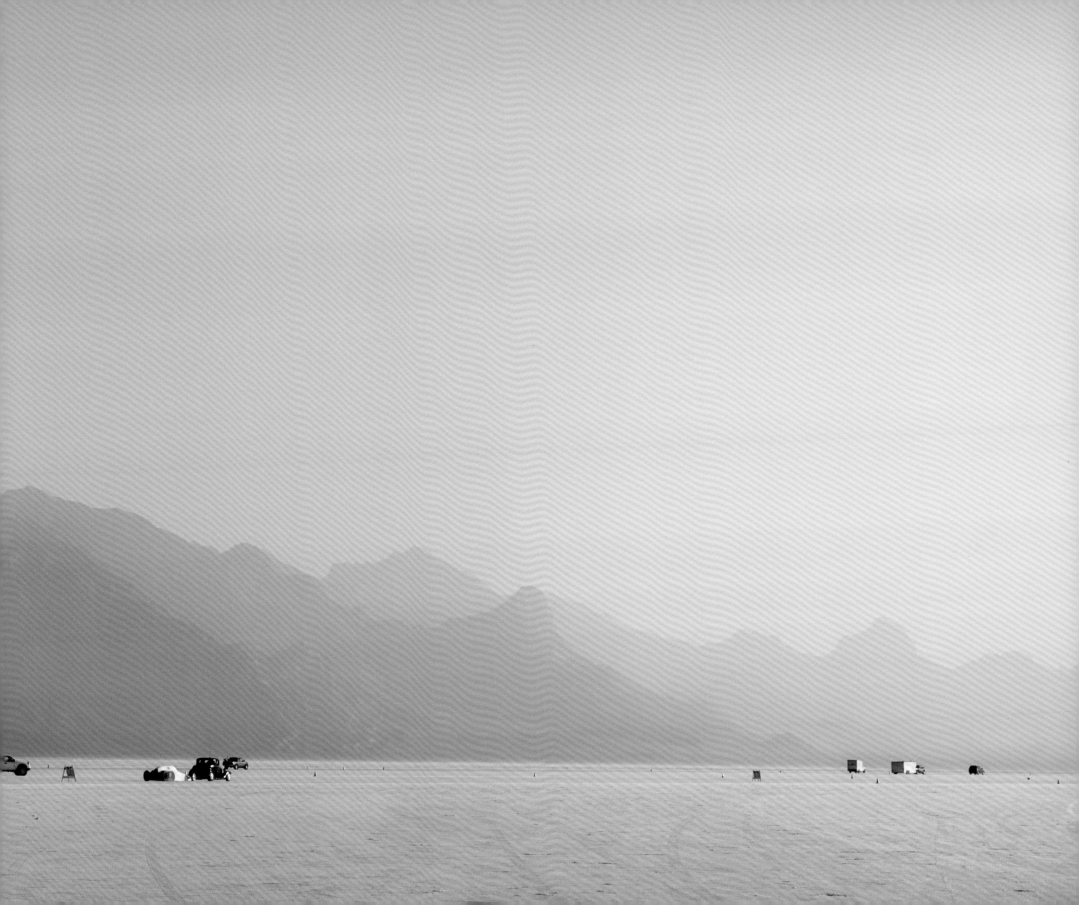

It feels like the edge of the world, like you could walk away and step off into another dimension, and it is likely that you could if you did not bring water, food, shelter, and a compass. The sun is blinding before midday and relentless afterwards, beaming back at you from the stark white salt. There are few if any signs of life; the animals and insects of the surrounding mountains learned long ago not to venture out onto this plain where horizons vanish into mirage or winter cloud cover... This landscape is best observed when it glows cool by the full moon. Should you wish to drive in a straight line as fast as you possibly can there is little to stop you, which is precisely why the Bonneville Salt Flats on the western edge of Utah have been famous for land speed racing since 1949, when the first ever "Speedweek" was held.

1949 was hardly the first time Bonneville's potential for a land speed record had been utilized. By 1939, Englishman John Cobb had bested Sir Malcolm Campbell's 1935 "Bluebird" record of 301.12 mph (484.61 kmh) and fellow Brit George Eyston's 1937 record of 357.50 mph (575.34 kmh). After the war, Cobb set the piston-engined, wheel-driven record at 394.19 mph (634.39 kmh). This record would stand for many years until another Engishman, Donald Campbell, ran 403.10 mph (648.73 kmh). The record would remain elusive despite the best efforts of home-grown American hot rodders like Mickey Thompson, who ran 406 mph (653.39 kmh) in "Challenger I" but could not make a return run fast enough to catch the record due to a broken driveshaft back in 1960. It was not until the Summers Brothers ran their naturally aspirated, fuel injected, quad 426 Hemi, streamliner up to a two-way average of 409.277 mph (658.67 kmh) in 1965 that the Americans could claim the honor of having the world's fastest vehicle. Consider this: Goldenrod cost approximately US$ 250,000; Campbell's effort was more like US$ 3,000,000.

Since then hundreds of records have been made and broken in every class of motorcycle, automobile, streamliner, and lakester with every sort of powerplant. There are several records for piston-engined, wheel-driven vehicles worth mentioning: First, longtime competitor Al Teague who finally broke the Summers' Brothers record in his "Spirit of '76" streamliner with a 409.986 mph (659.81 kmh) two-way average, then came the Burkland family who broke them all with a two-way average of 417.020 mph (671.13 kmh). As of 2013, the record for a wheel driven vehicle is held at an unbelievable 437.183 mph (703.58 kmh) by the Poteet and Main "Speed Demon" streamliner. This little 'liner is has a blown "C" class engine, which means way less motor, yet way more power, and some extremely refined ideas. In an entirely different class of non-wheel-driven vehicles, on the other side of Nevada, the Thrust SSC jet car broke the sound barrier at 763.035 mph (1,227.99 kmh) on the Black Rock desert in a shockwave of dust in 1997.

Today's driver bears no resemblance to the leather-lidded 'rodder of the past, but under the full face helmet, in a firesuit, strapped between the bars of the cage, there is the same spirit and de-

sire. There is no stereotype among drivers these days; they run the gamut of personalities, sizes, and shapes. They all love to go fast, they do it out of pure passion, and they all seem to share a very pragmatic side that borders on cold when they leave the line; there is a job to do. One driver explained that he would "rather build them" than drive them, which speaks to a desire to see the entire project through and get the record. Another, whose engine caught fire at nearly 200 mph (321.87 kmh), declined to pull the fire extinguishers, stayed cool enough to bring the car to a stop, then got out and doused the flames. People wreck then drive again the next year. It's not enough to say "adrenaline junkie"; it is better to say, "razor sharp."

Midway down the course lie the pits, the daytime home of mechanics, drivers, families, friends, and hangers-on. Fully equipped temporary garages are set up along with the coolers, the bar-b-ques, and the pop-up shade. Every style is represented, from the mobile home, tractor trailer big-rig operations to the single shade, four lawn chair pickup truck oasis. The people watching in the pits is extraordinarily good. Entire families come along and it is not uncommon to see three generations of a family at work or play. Despite the frenzy of preparation or repair that exists from pit to pit, the atmosphere is friendly, laid back. People help one another with parts and labor or simply a cold drink and a good story.

During the latter part of the day, as the "magic hour" approaches, photographers round up their subjects to catch the last rays like birds on a wire at sunset. Crews begin to pack up, and the time comes when spectator and participant alike really begin to mingle. The fans are just as hard core as the crews and drivers; they are die-hard gearheads and motorsports fans there for the vicarious thrill of speed just as any fan of team sports is there for the vicarious thrill of victory.

Just off the salt proper is "the bend in the road gang," where a very American caravan comes to life as night falls down. Everyone has a story to tell of past Speedweek adventures or the crazy road trip out there this year. They come for the speed and the cars, to show off their own customs, to wear funny hats, take pictures, shoot the shit, and ride bicycles camp to camp, fire to fire, beer to beer. They know their "who's who" and their "what's what"—and they know this place, their brains are wired for this week. If you like to mix talk of camshafts with movies, mysticism with pistons, or aerodynamics with natural history, this is your tribe. The night sky and matching expanse give rise to such talk and camaraderie until the wind wicks wild and throws us all around for fun.

The bend in the road is only one part of the immediate vicinity. The mountains to the north are where many an "outlier" camps and finds solitude on a blanket under the stars. The Silver Island mountain range here is known for its caves bearing evidence of ancient human occupation and a stark beauty. During infrequent, heavy rain they wash their minerals out to replenish the flats

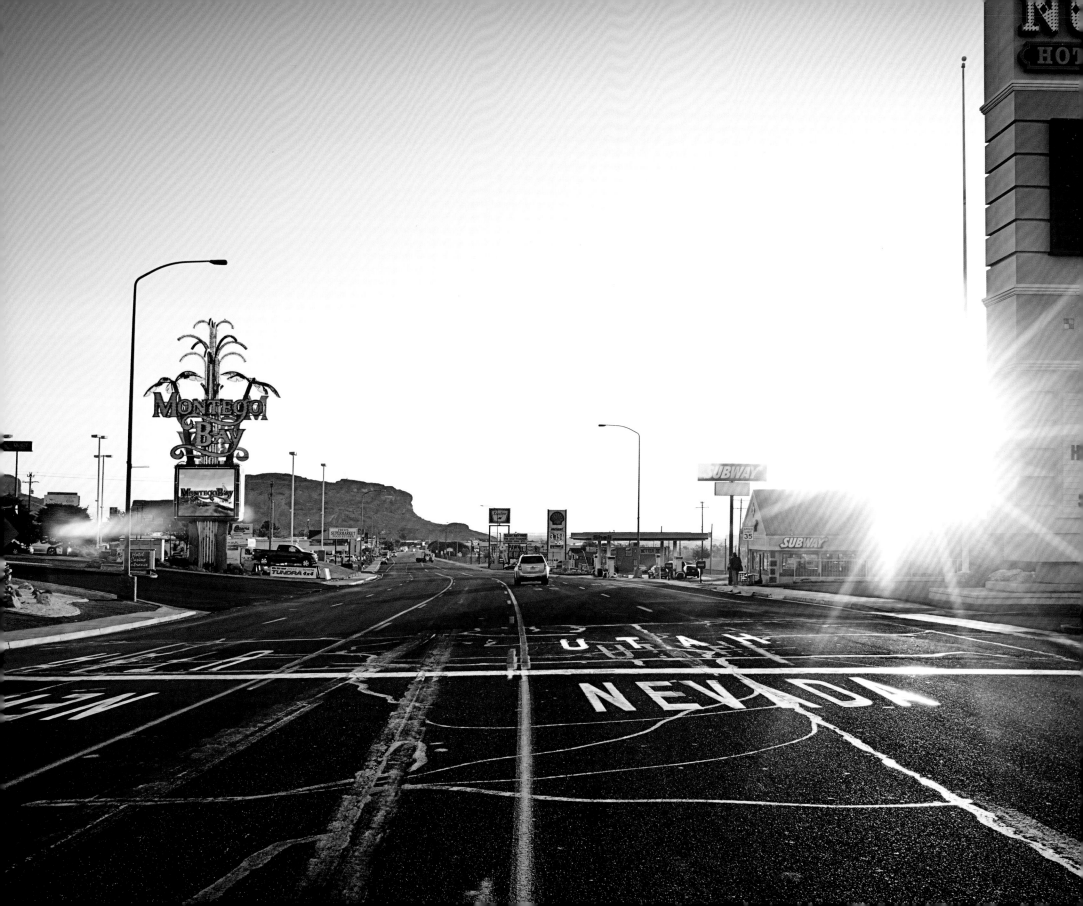

which are slowly shrinking due to Potash mining. All along the jagged peaks the waterlines of the ancient Lake Bonneville are visible and one can imagine the life the ancient people might have had; but the truth is that not every one is ready to kick scorpions around, and for that there is Wendover.

The town of Wendover is actually two towns split in half by the Utah/Nevada border. The Nevada side has gambling, girls, and a decidedly fake party oasis feel while on the Utah side it is life as usual for a small desert town on the edge of nowhere where the beer is low alcohol by law and the median family income is roughly half of what the rest of the state earns. The people who serve the gamblers, make their beds, and flip their burgers mostly live on the Utah side. The real estate on the Nevada side is reserved for making money off of bedraggled motorists or, in the summer, off of the racers and their fans when the prices for everything in town go through the roof, earning the town the less than affectionate nickname, "Bendover."

In the 1940s, Wendover was considered so distant that it was chosen as the airbase for training the crews of the "Enola Gay" and "Bockscar"; the two B-29 Superfortress bombers that dropped atomic bombs on Hiroshima and Nagasaki in 1945, bringing about the end of World War II. The airfield is still there in East Wendover, though now it is a civilian airport, and traces of the old military presence make for a fun walking exploration of the old barracks and remaining hangars. It's a quiet ghost-town feeling with the only sounds being the highway, the occasional flight taking off, or the oompah of Norteno narcocorridos booming out of a flashy pickup truck. If you look carefully amongst the abandoned barracks you will find that one is an art gallery with work from the rotating artists in residence who live in a trailer by the airfield courtesy of CLUI: the Center for Land Use Interpretation.

It is fitting that a remote outpost of the arts is tacked onto the edge of the Great Basin next to a remote outpost of motorsports on the great salt desert. There is a link between the rule-bending, ingenious mindset of a designer/builder working within rule constraints and a musician working within a genre restriction; there is a link between the muscle memory of a dancer and that of the land speed driver. A few times a year they meet in the sublime racket of open exhausts and human interaction. The future is going faster… it's right now.

—Kevin Robert Thomson

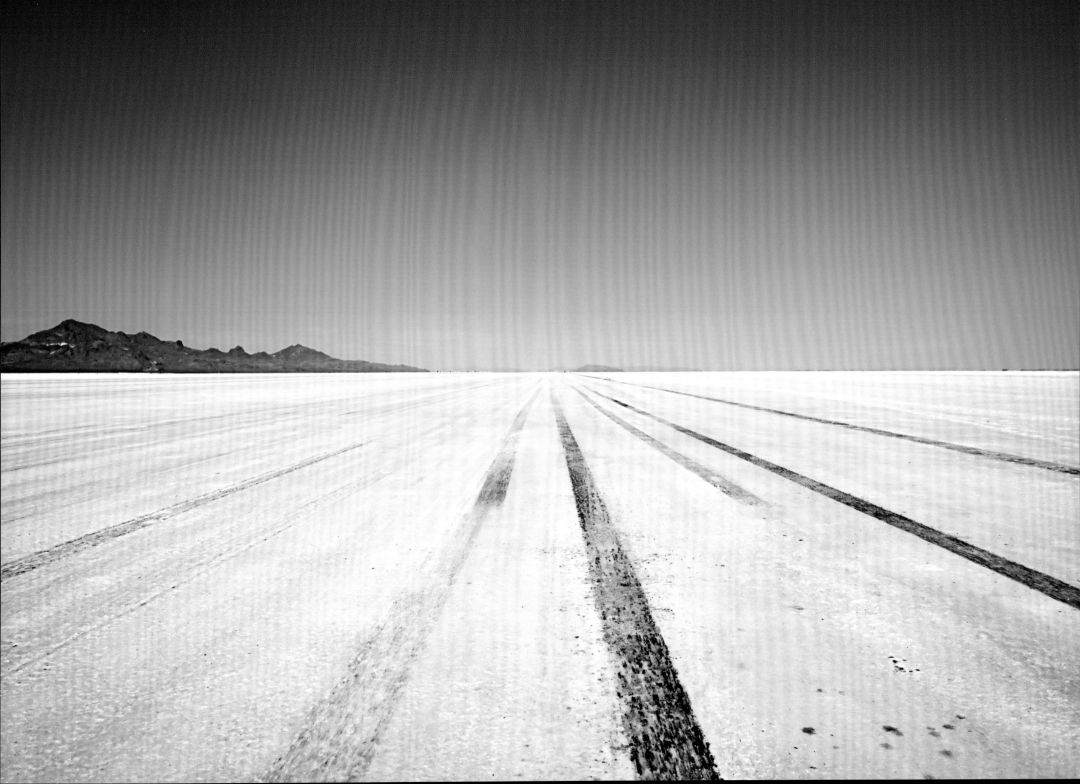

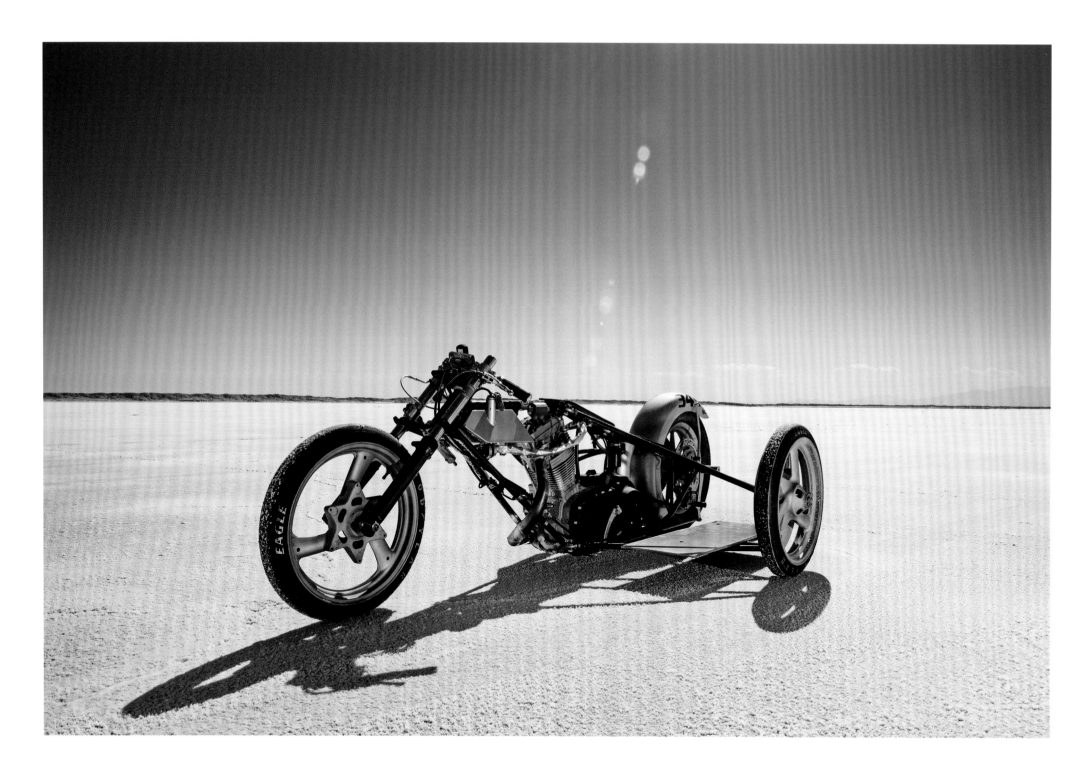

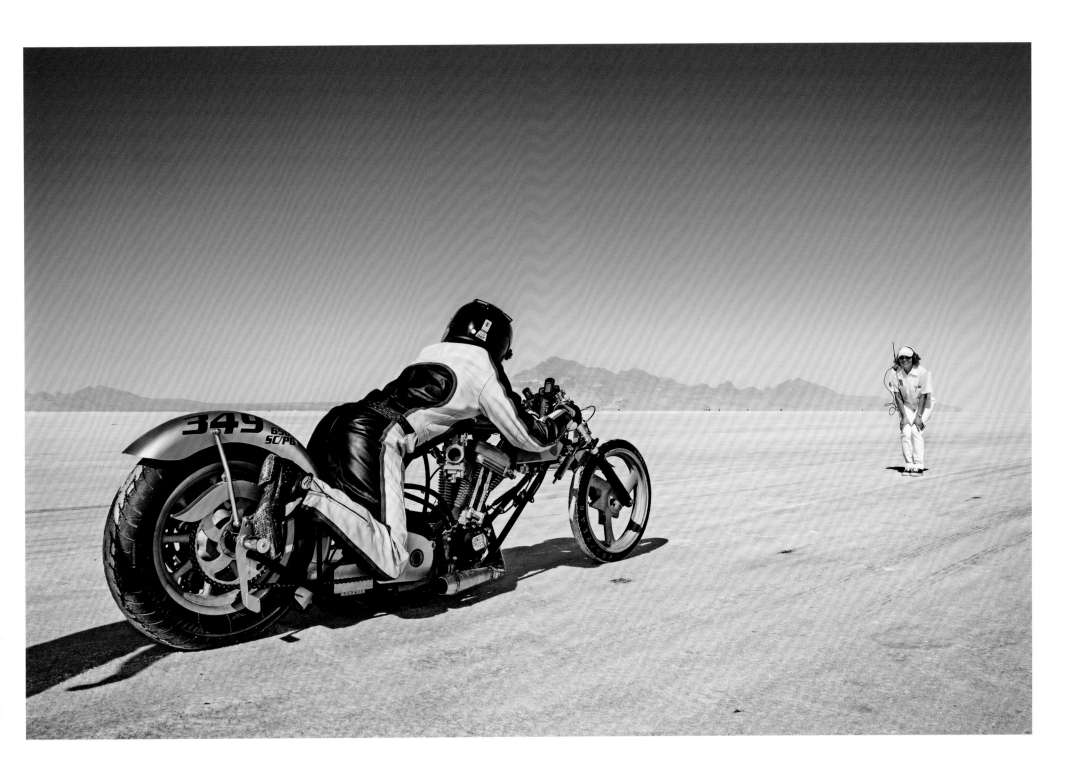

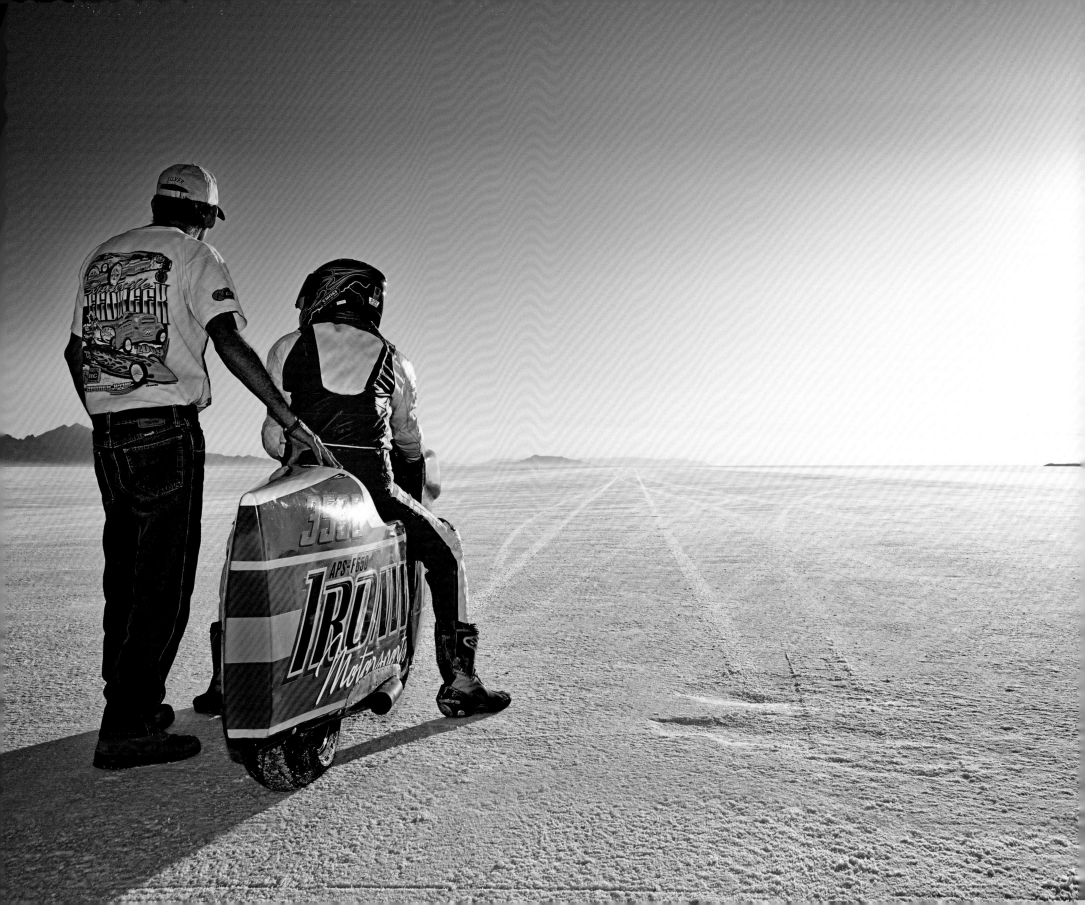

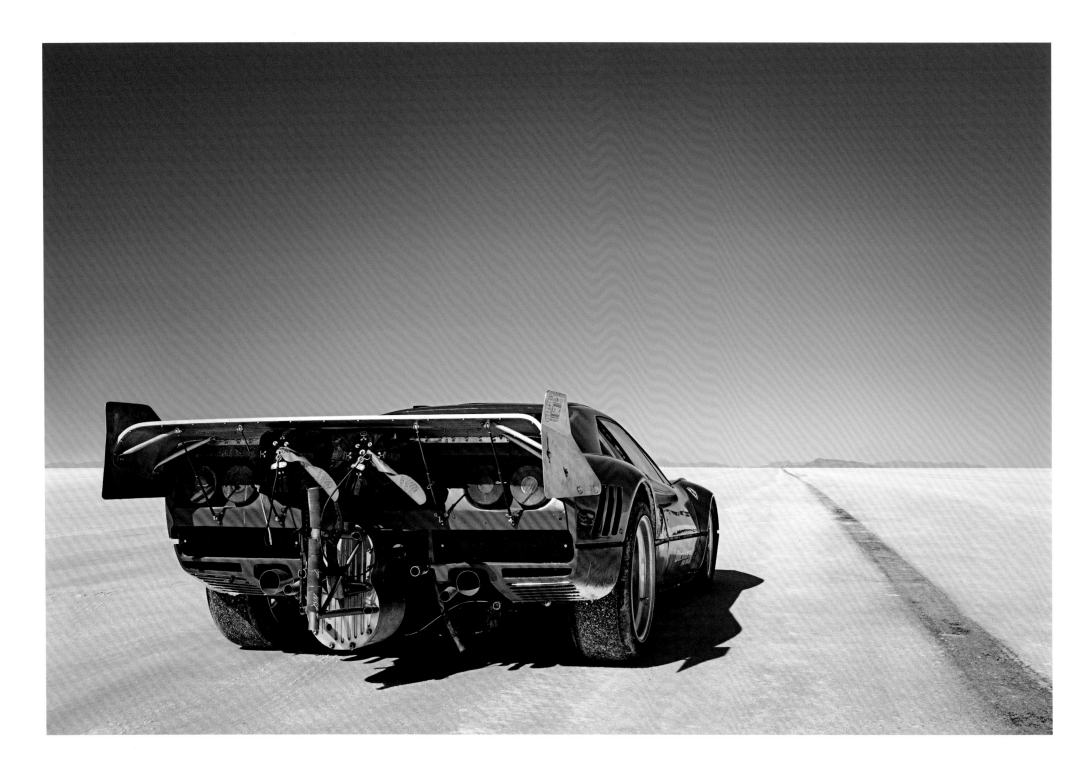

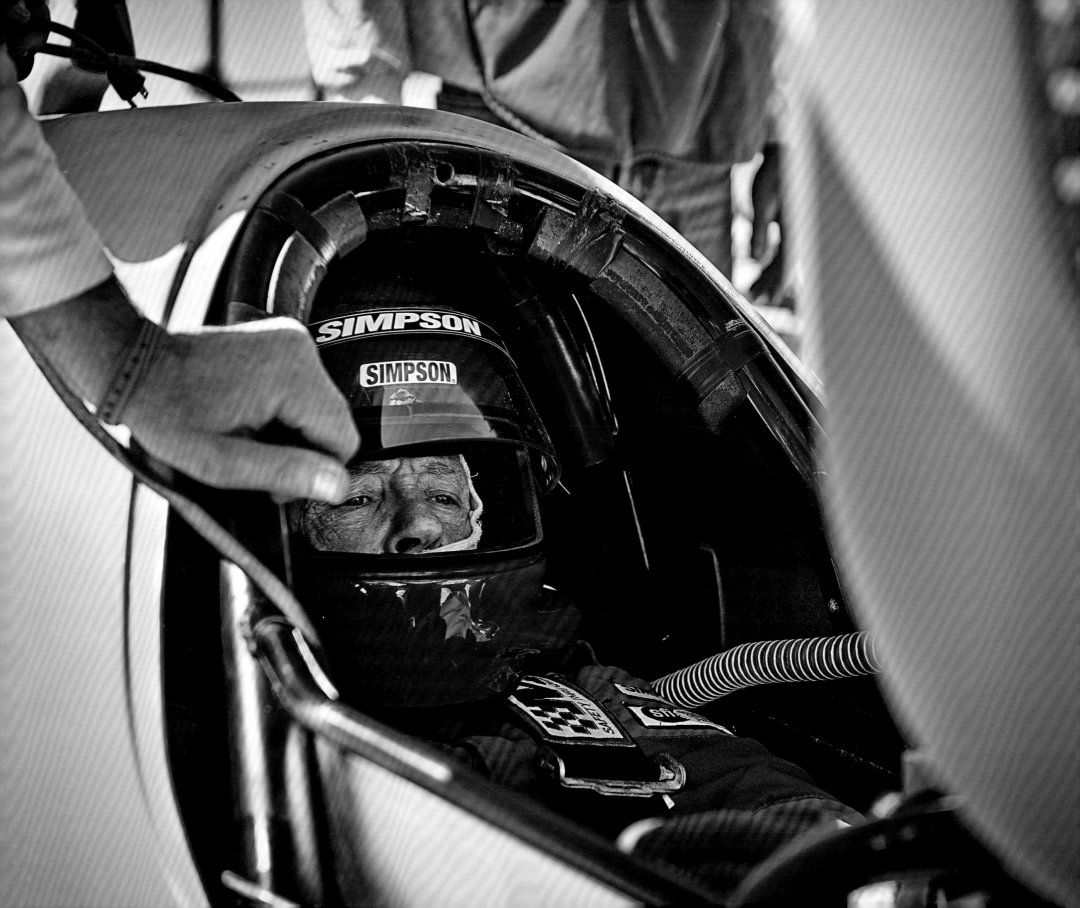

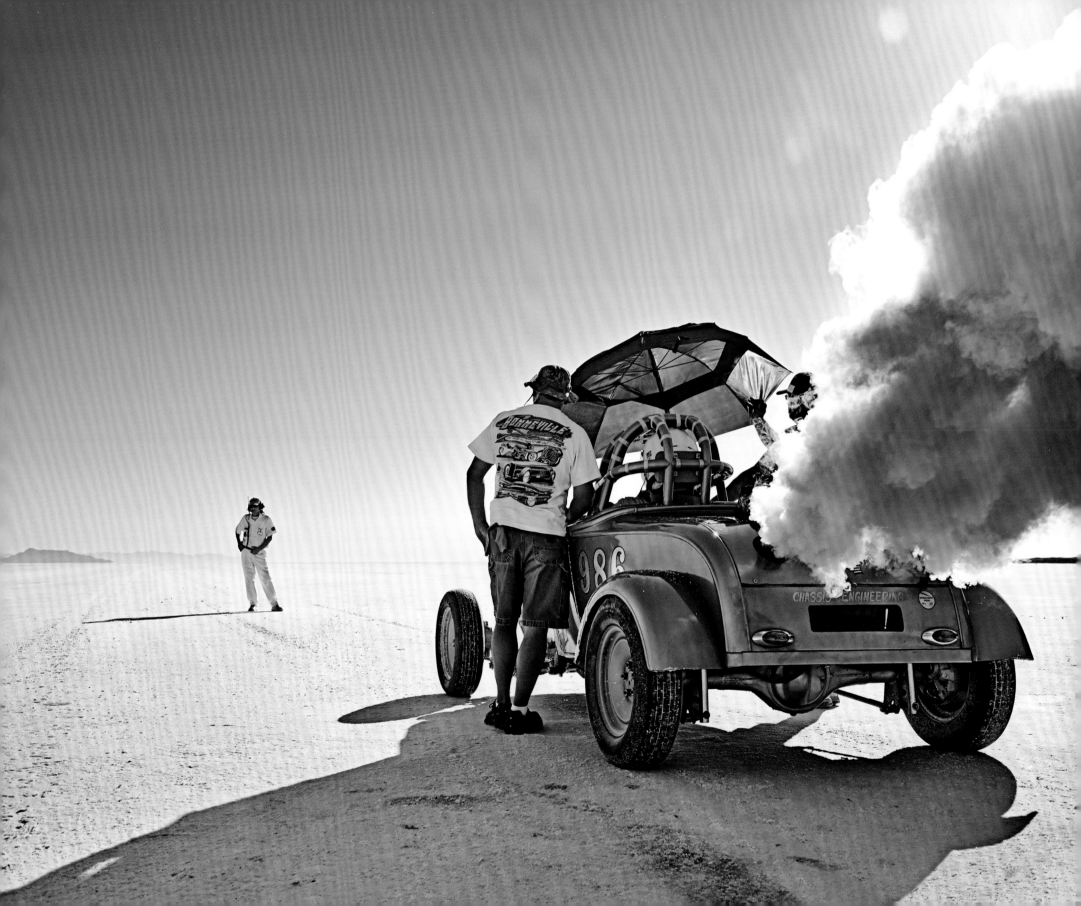

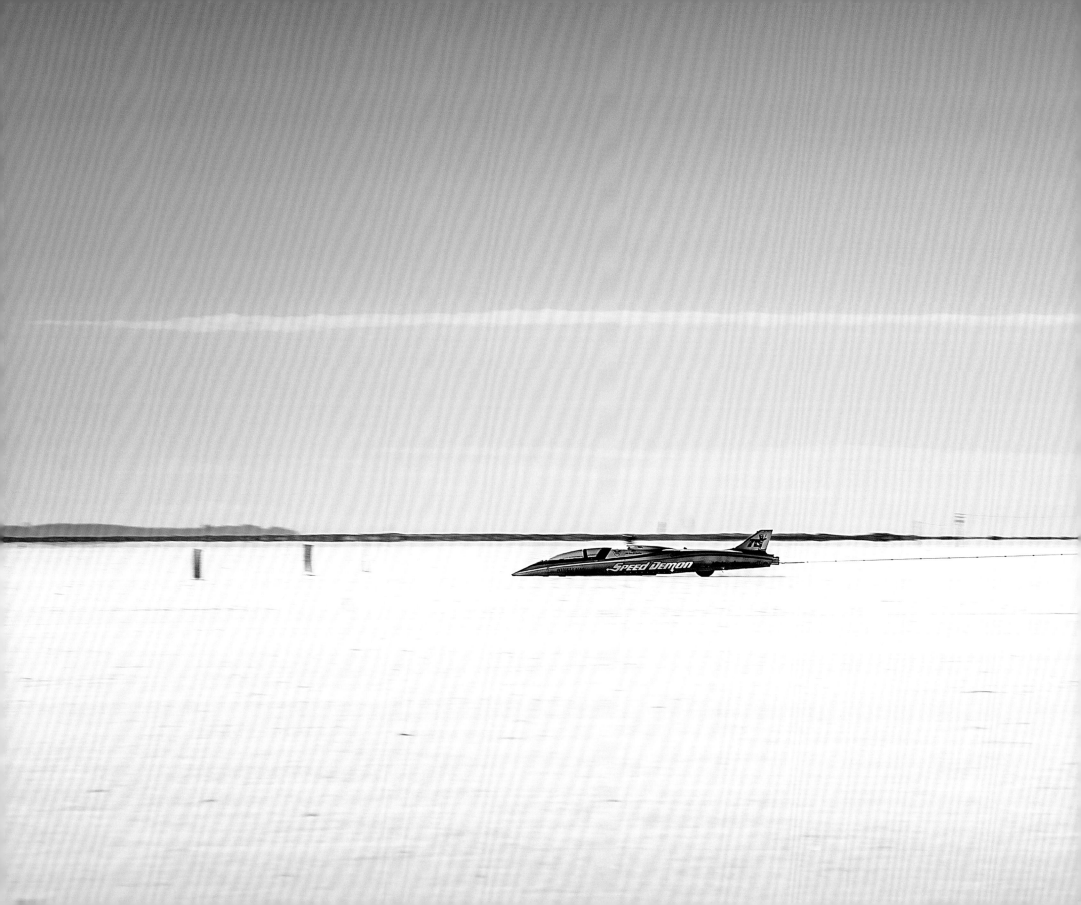

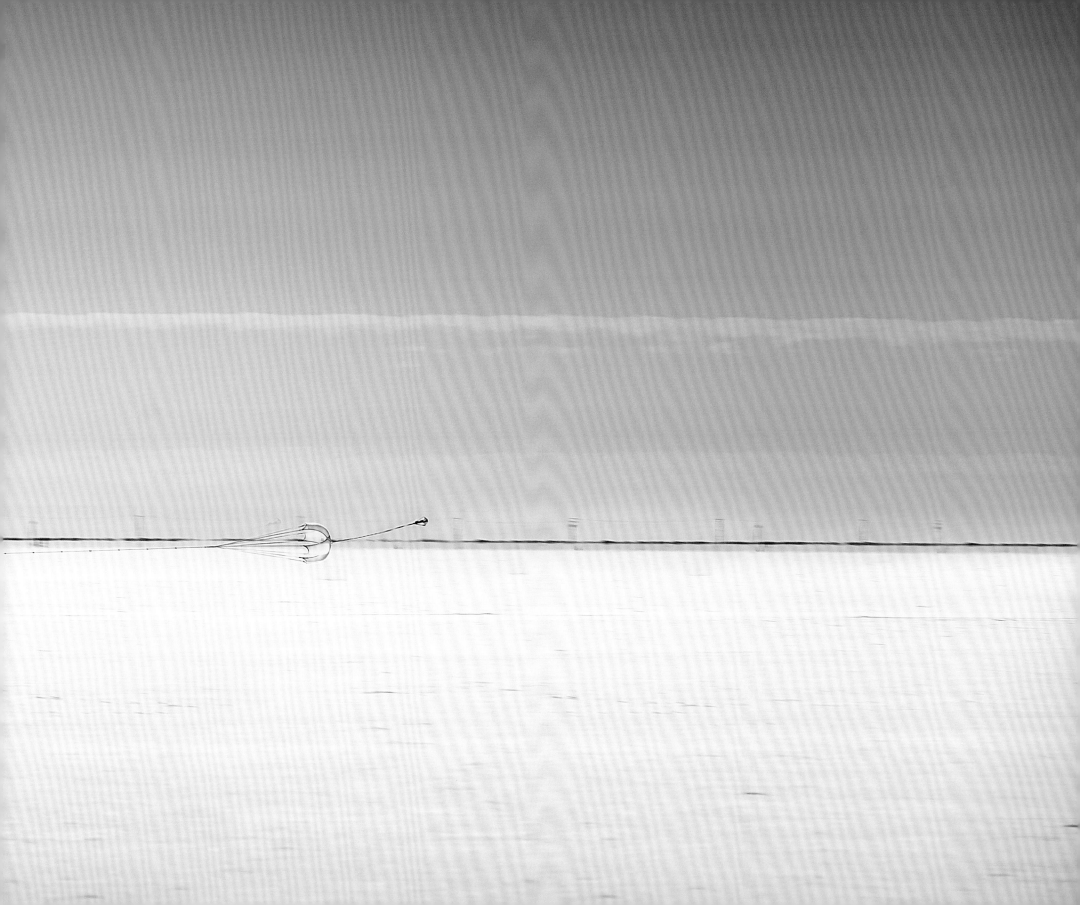

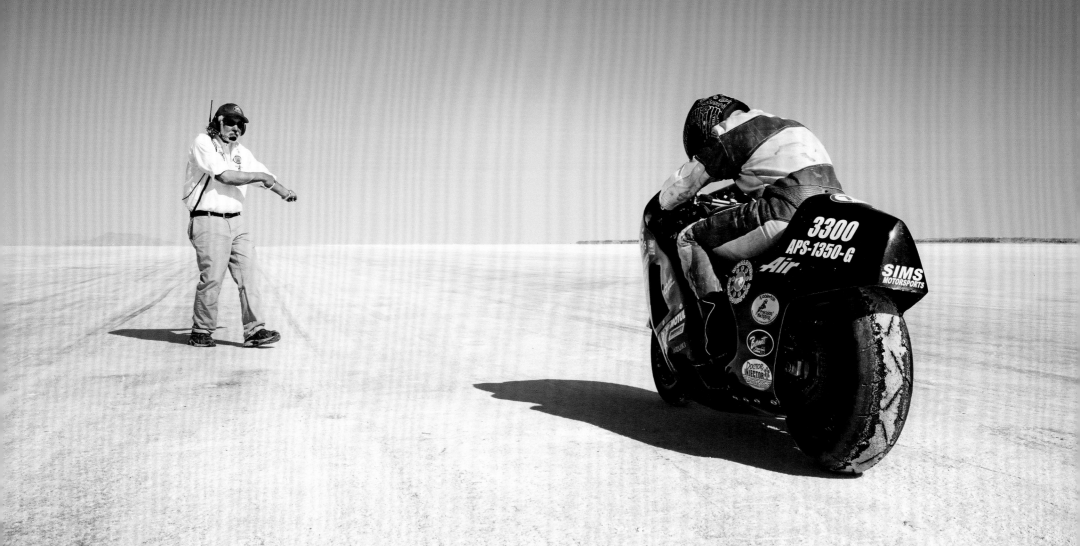

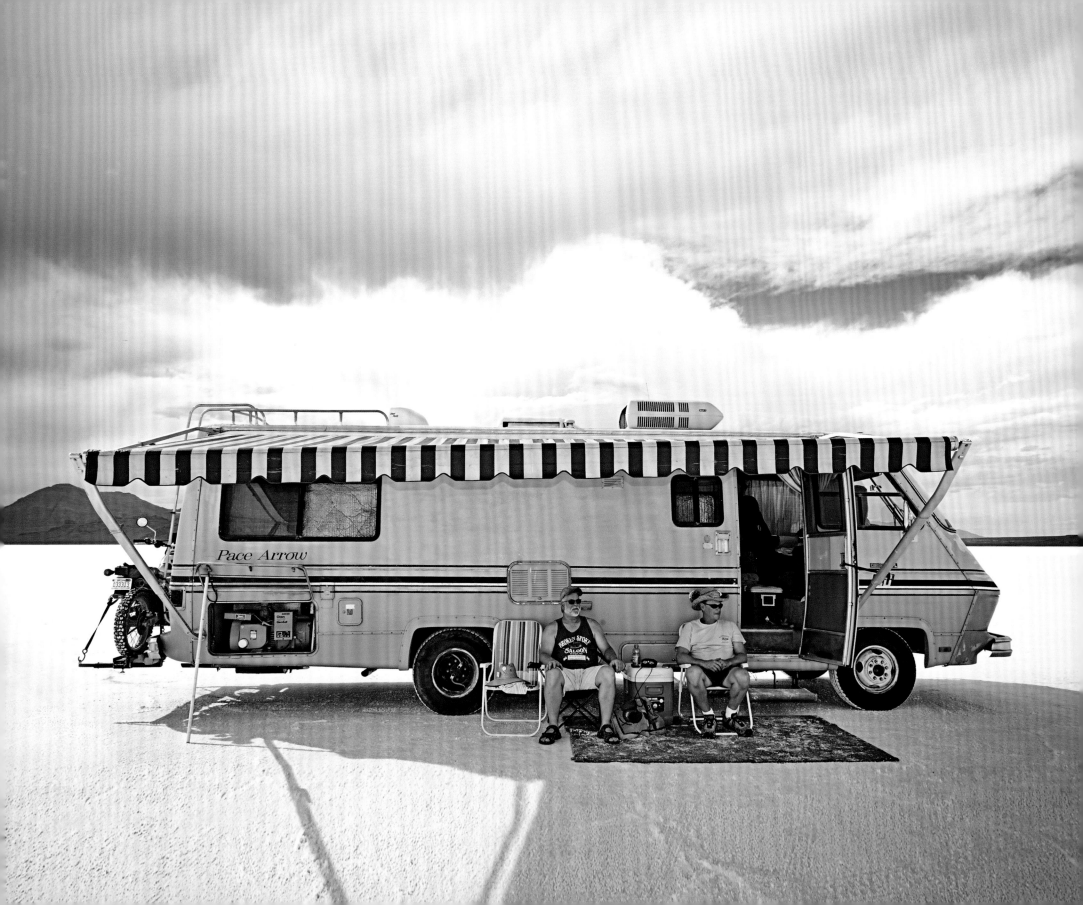

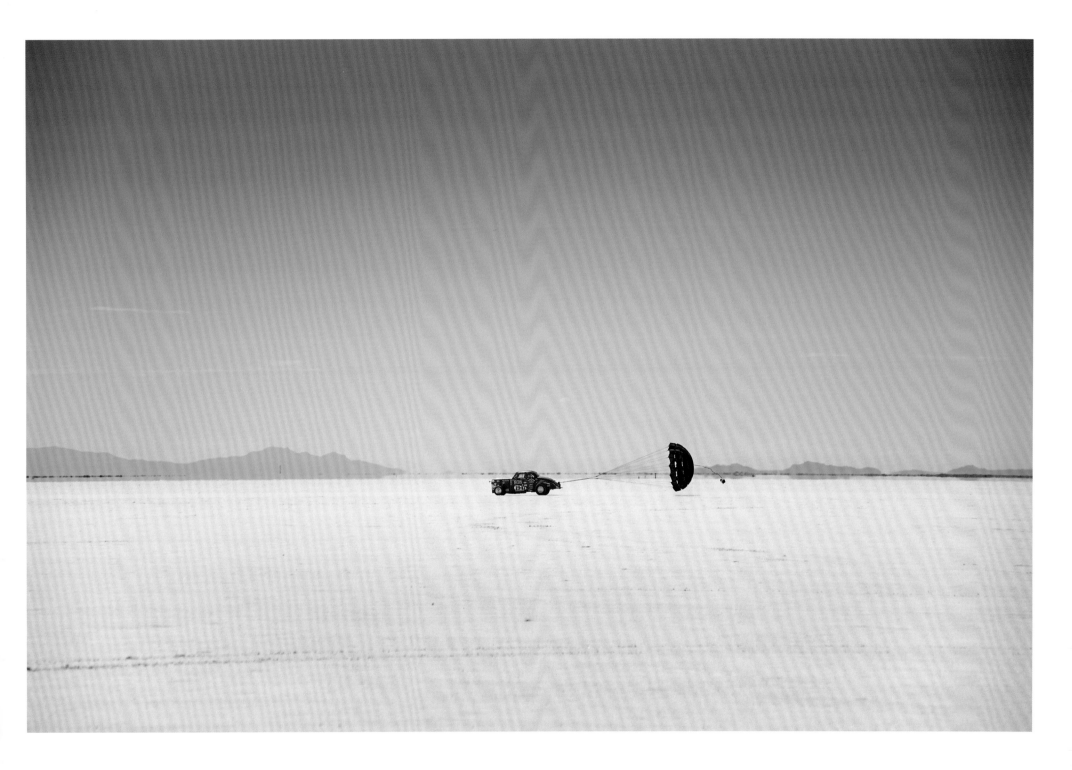

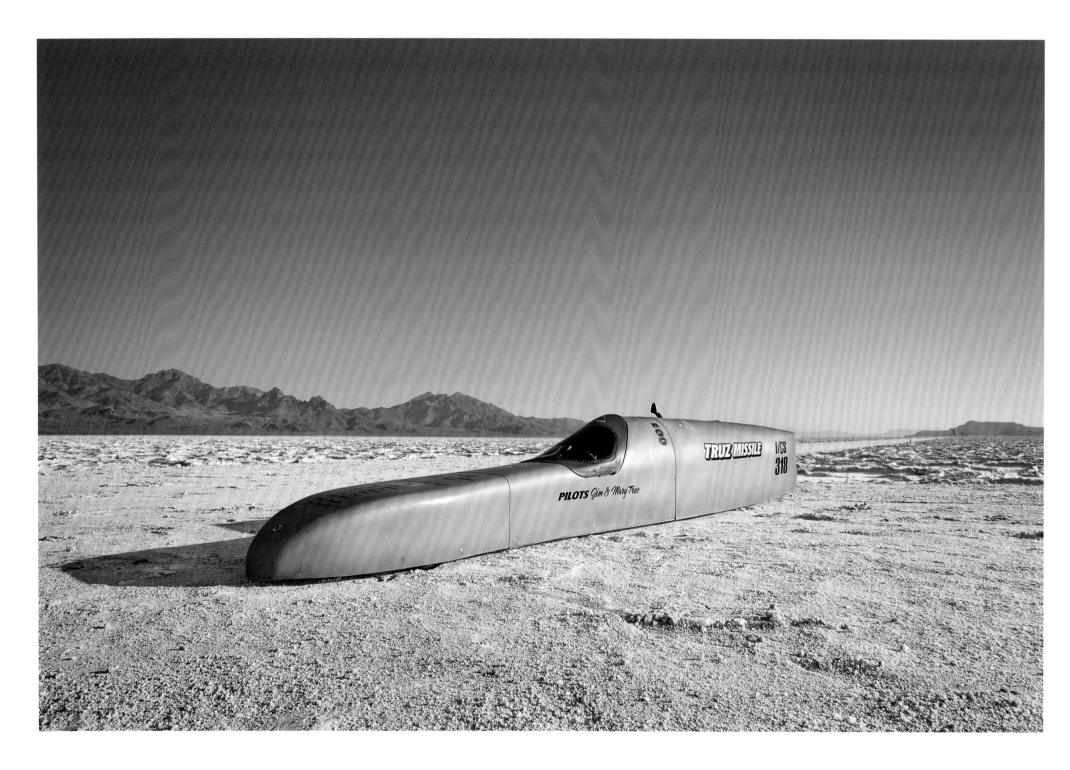

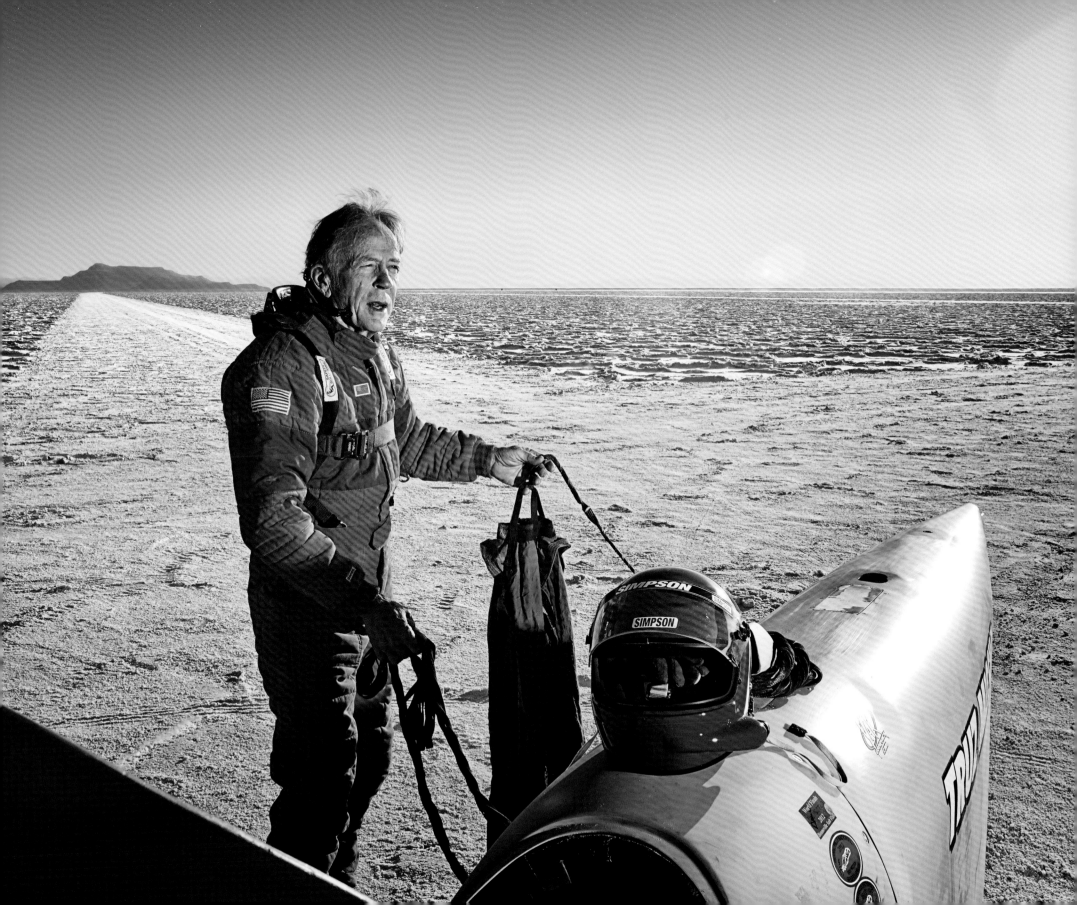

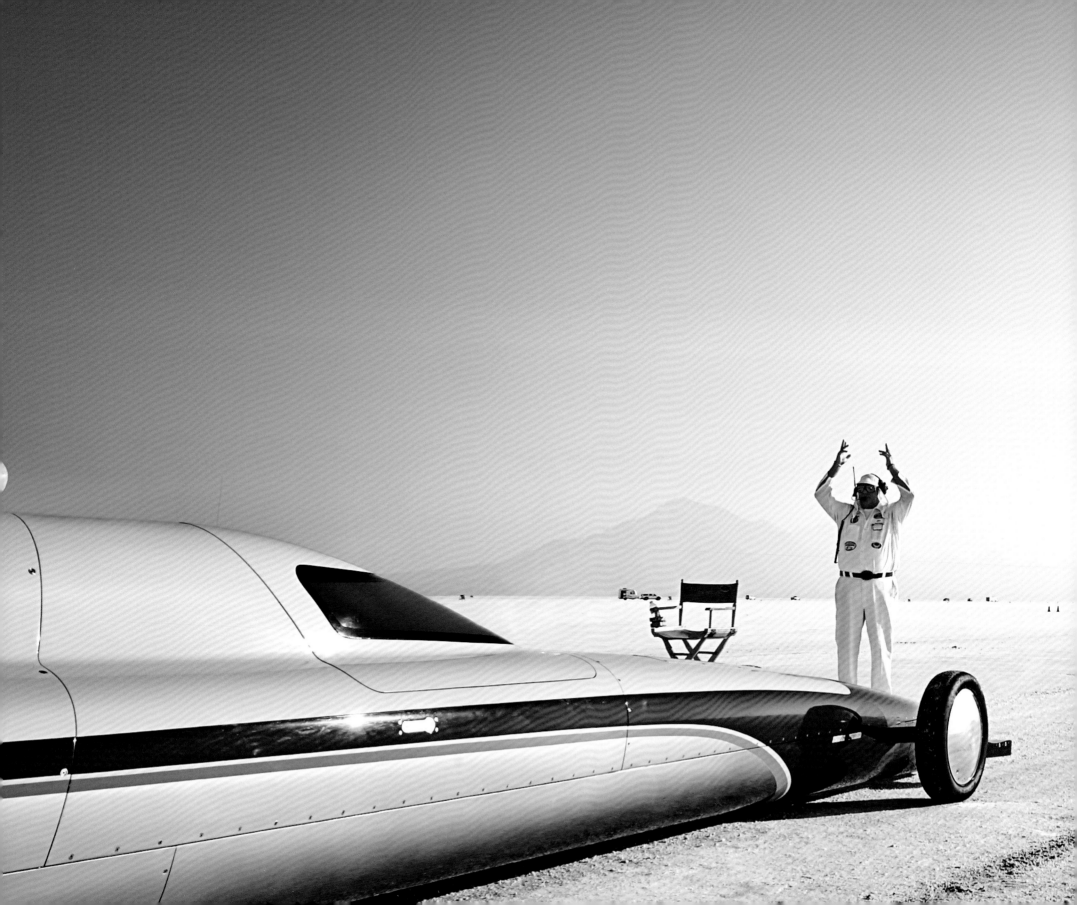

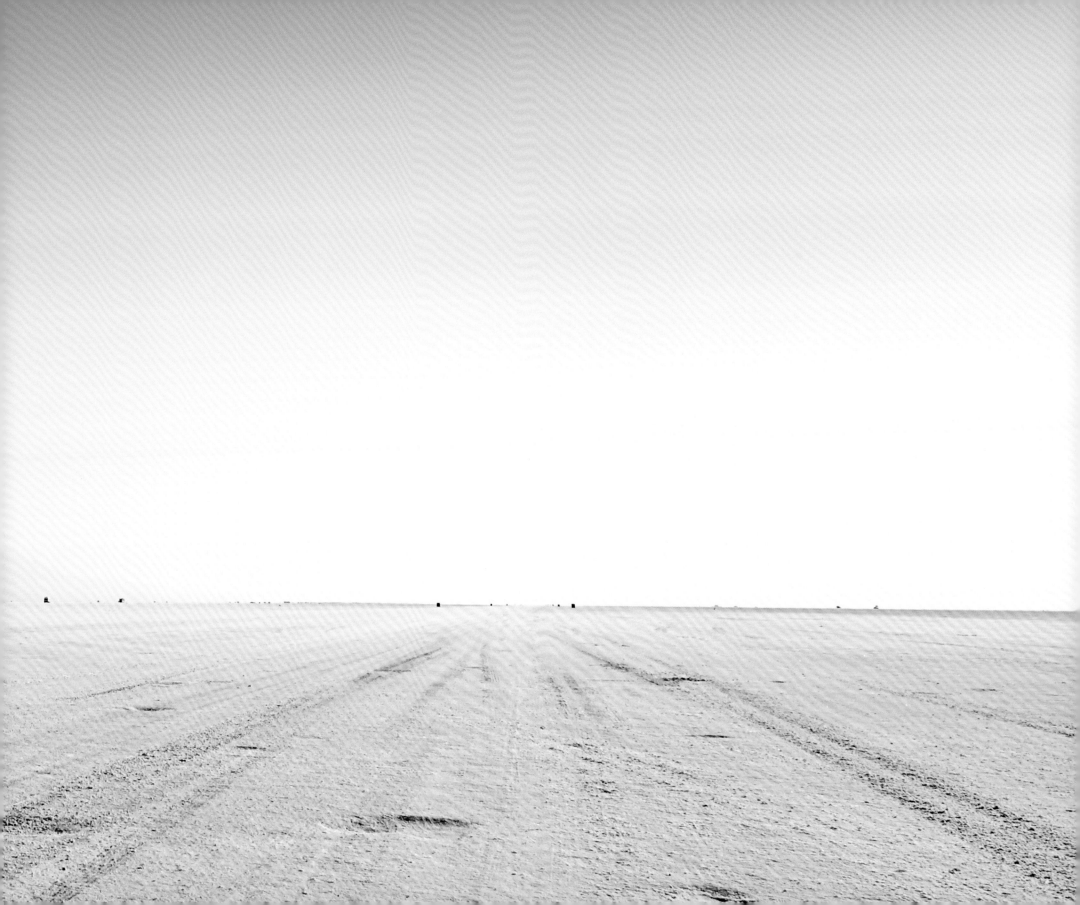

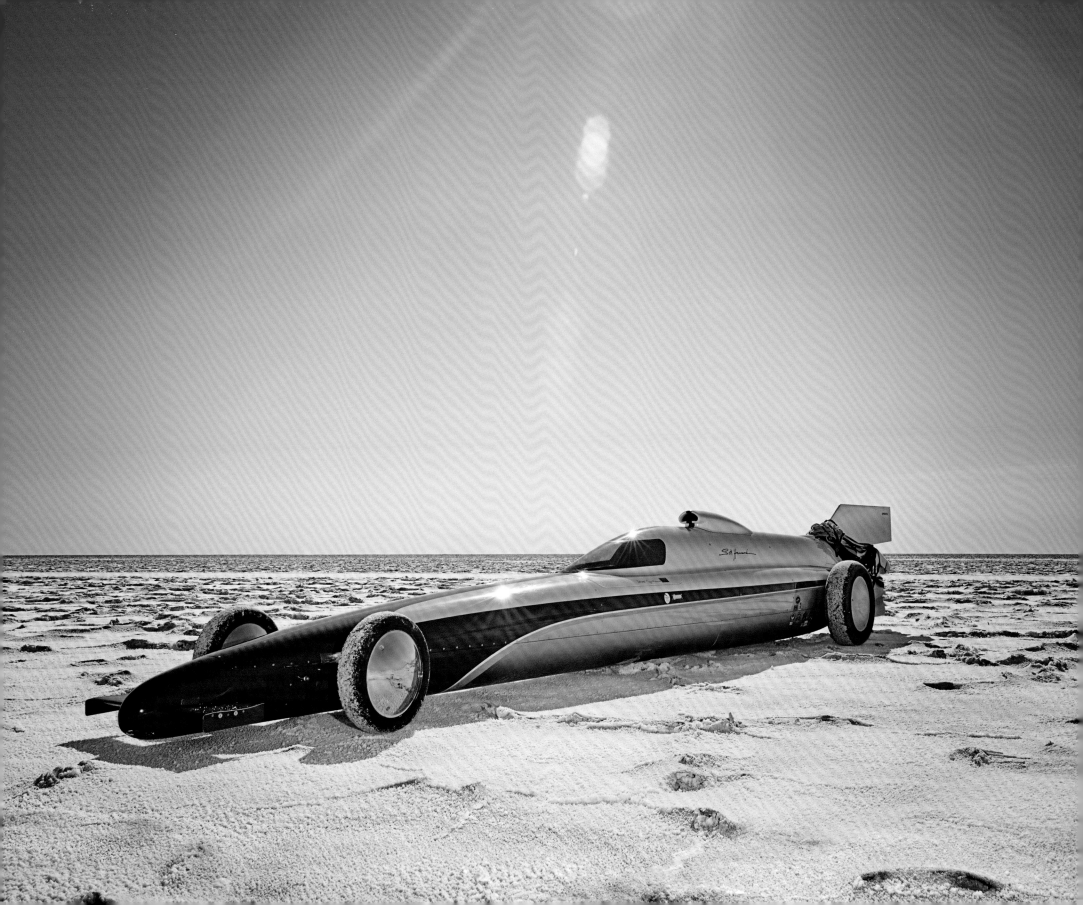

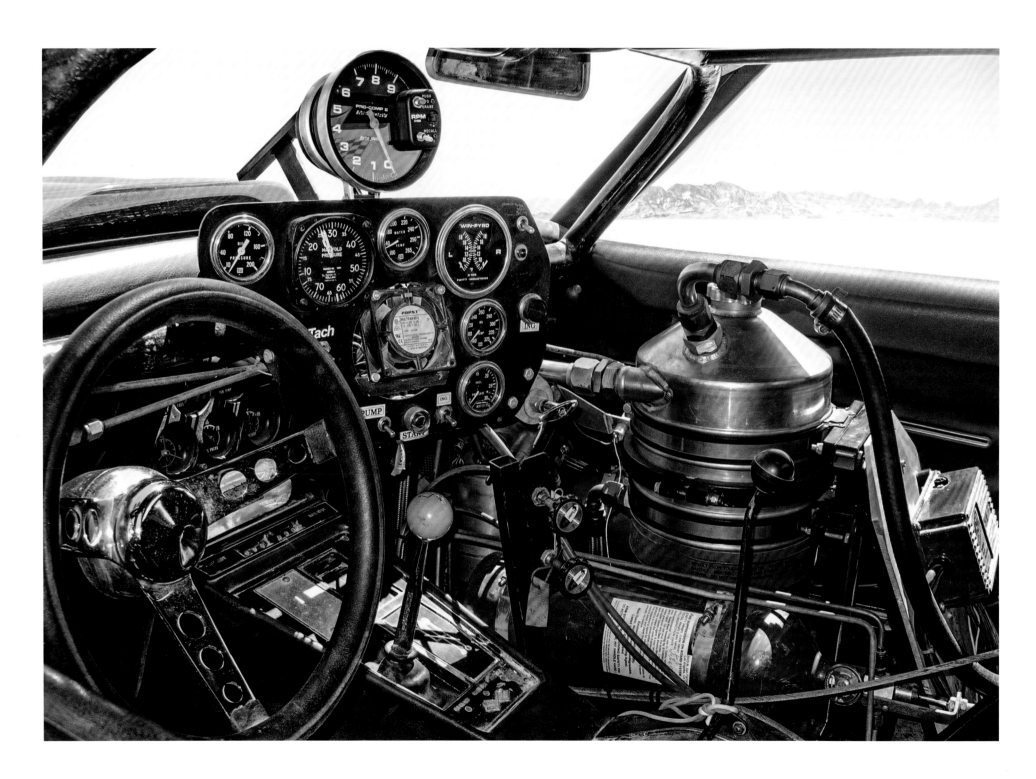

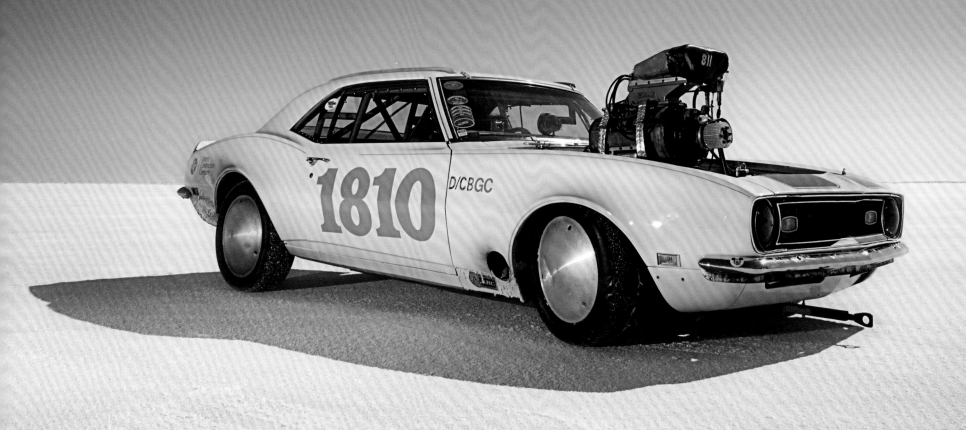

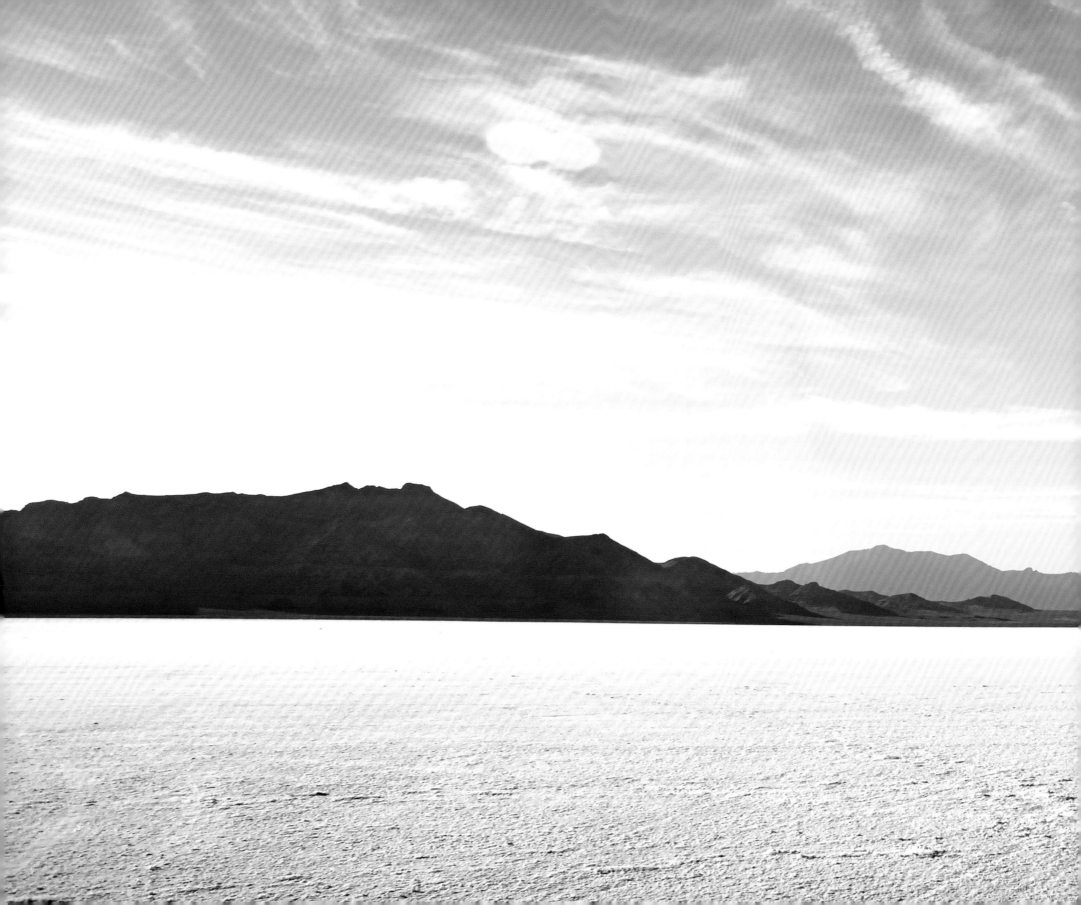

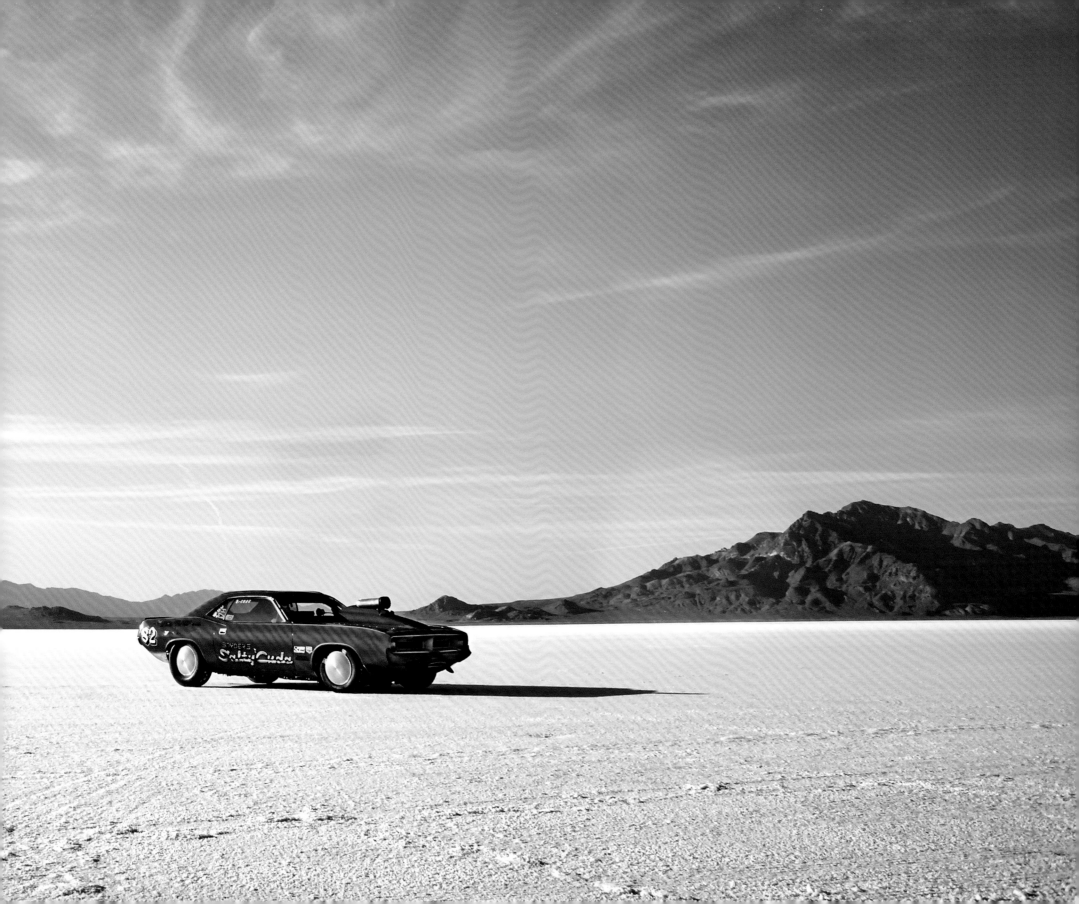

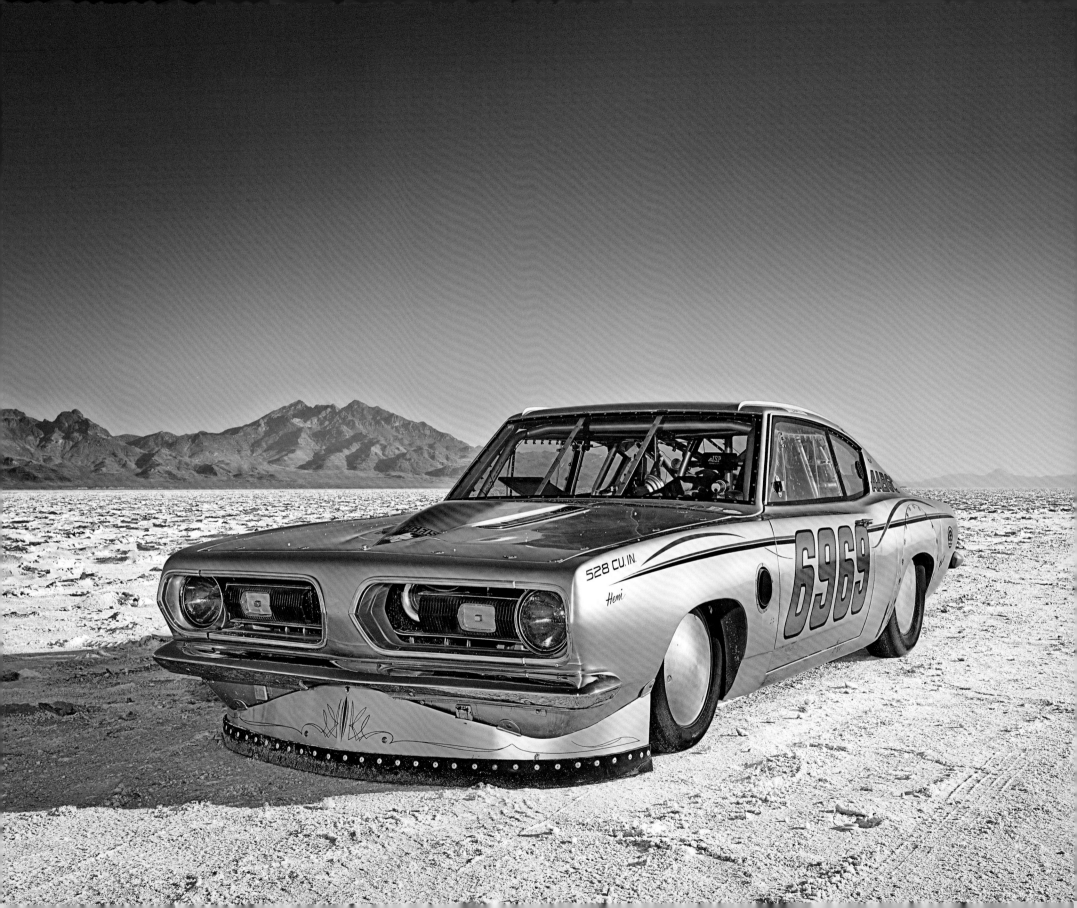

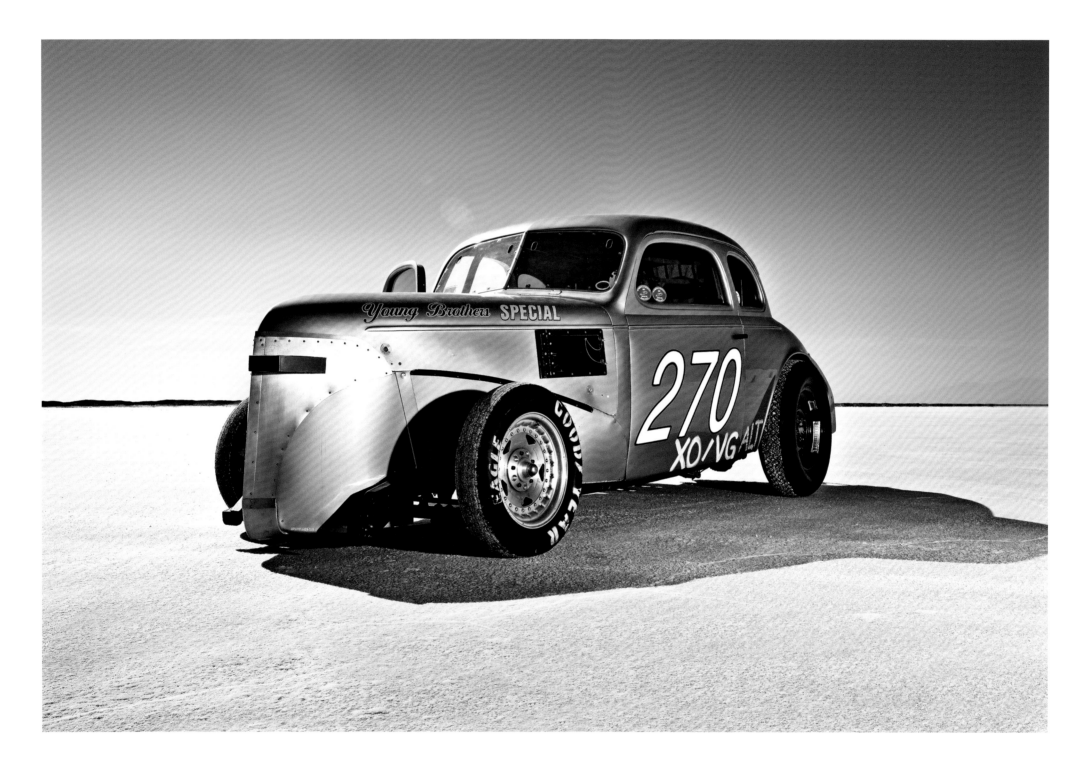

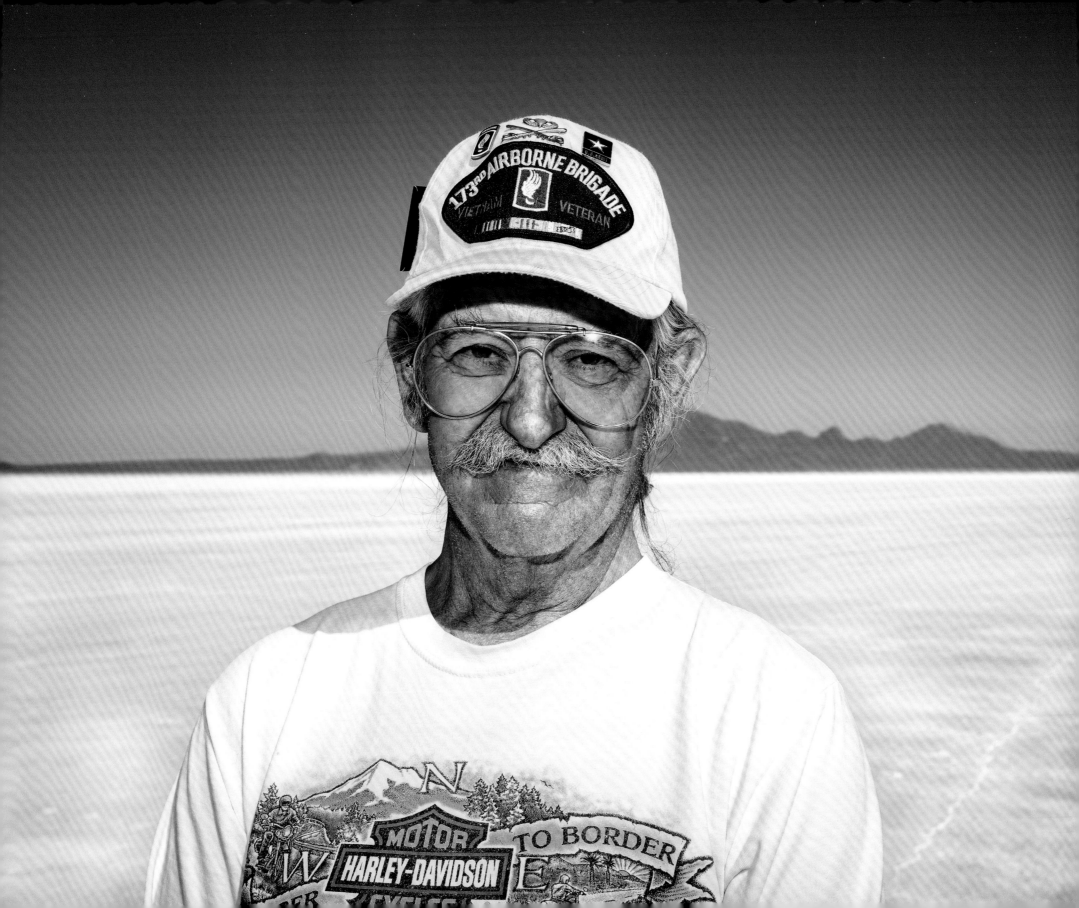

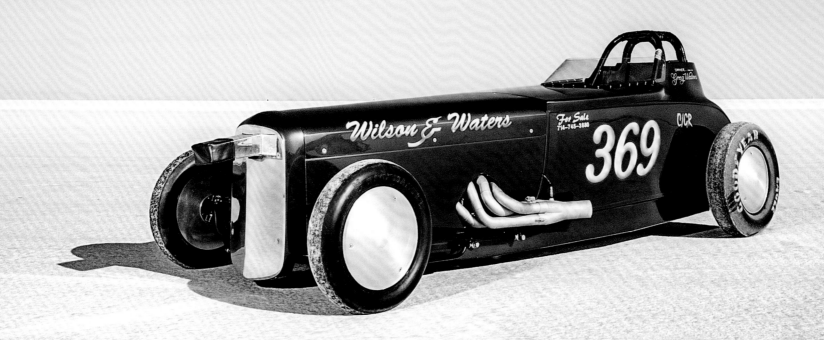

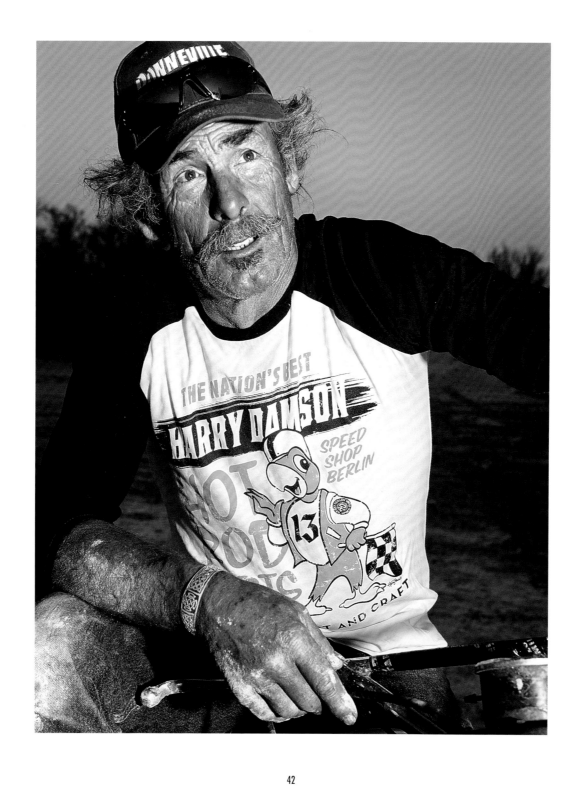

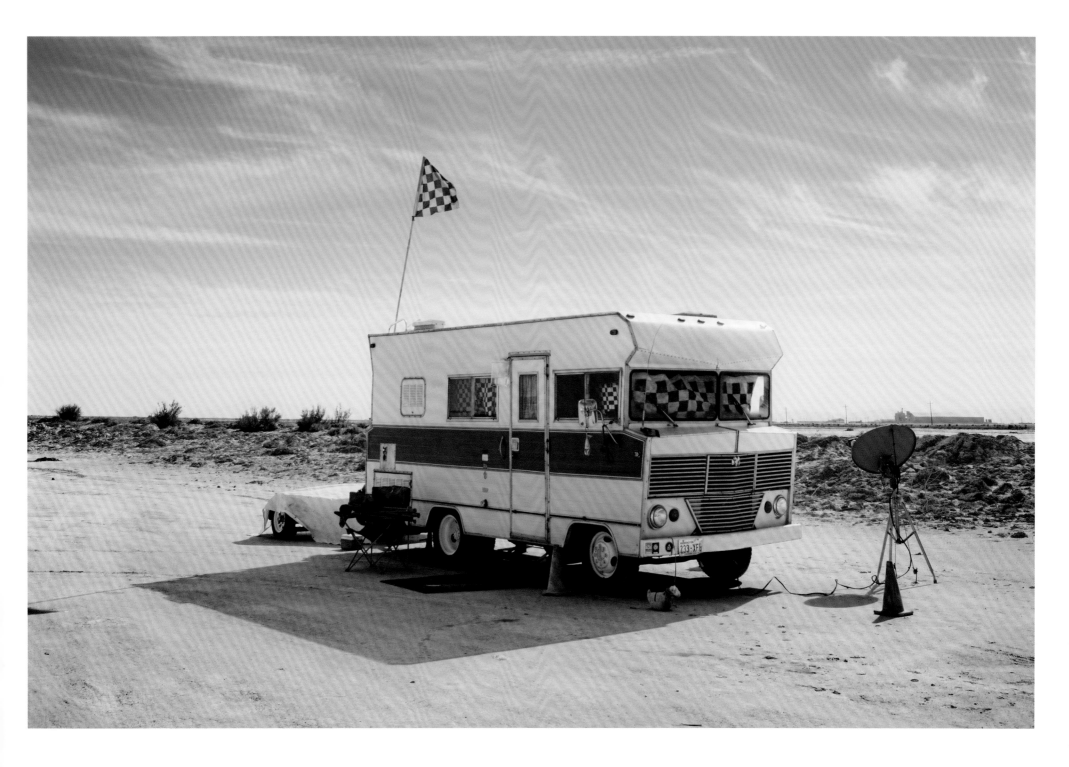

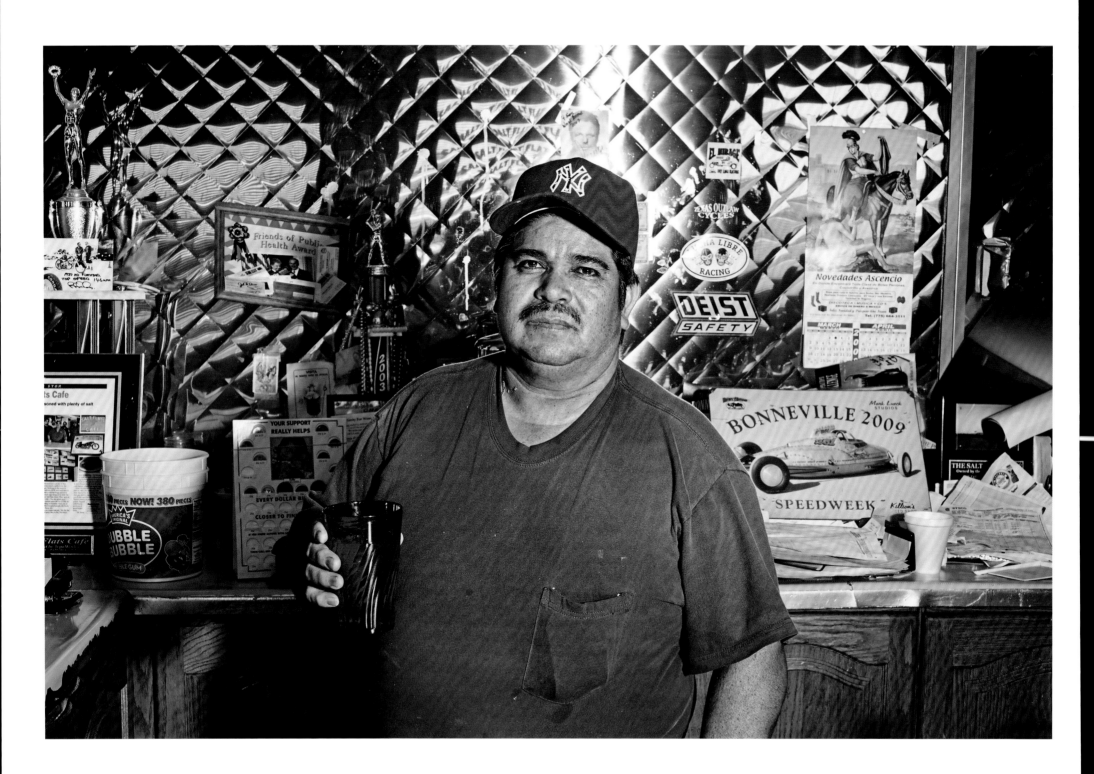

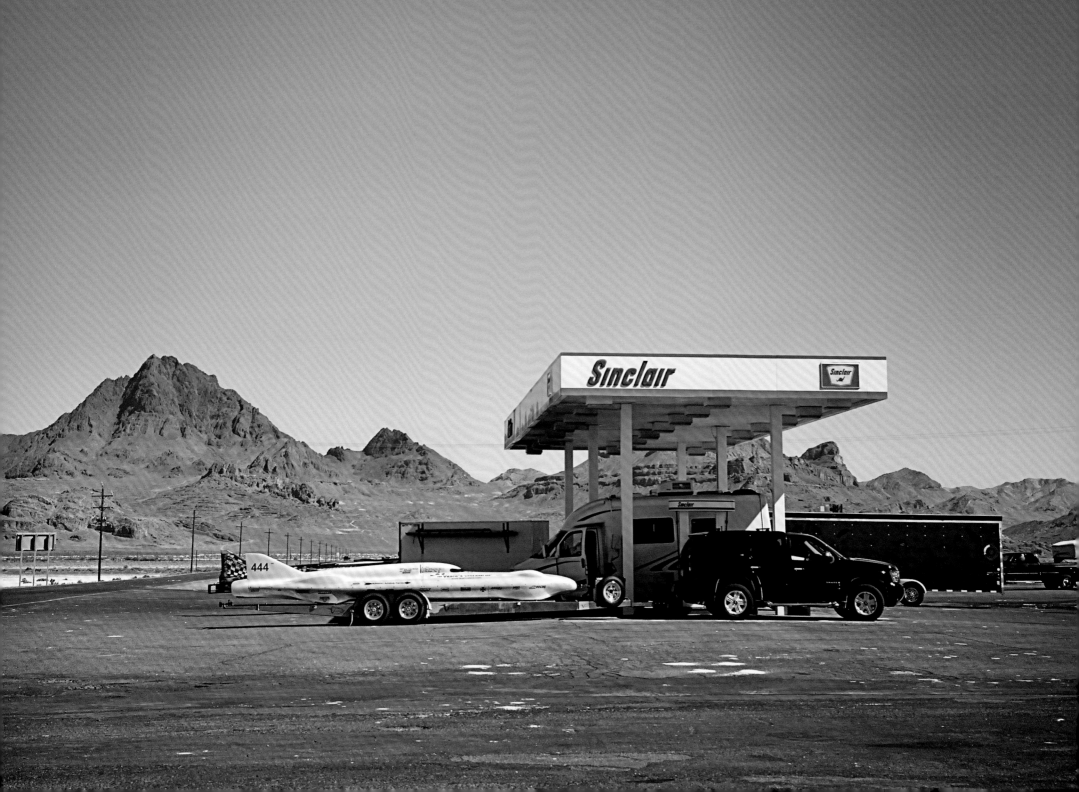

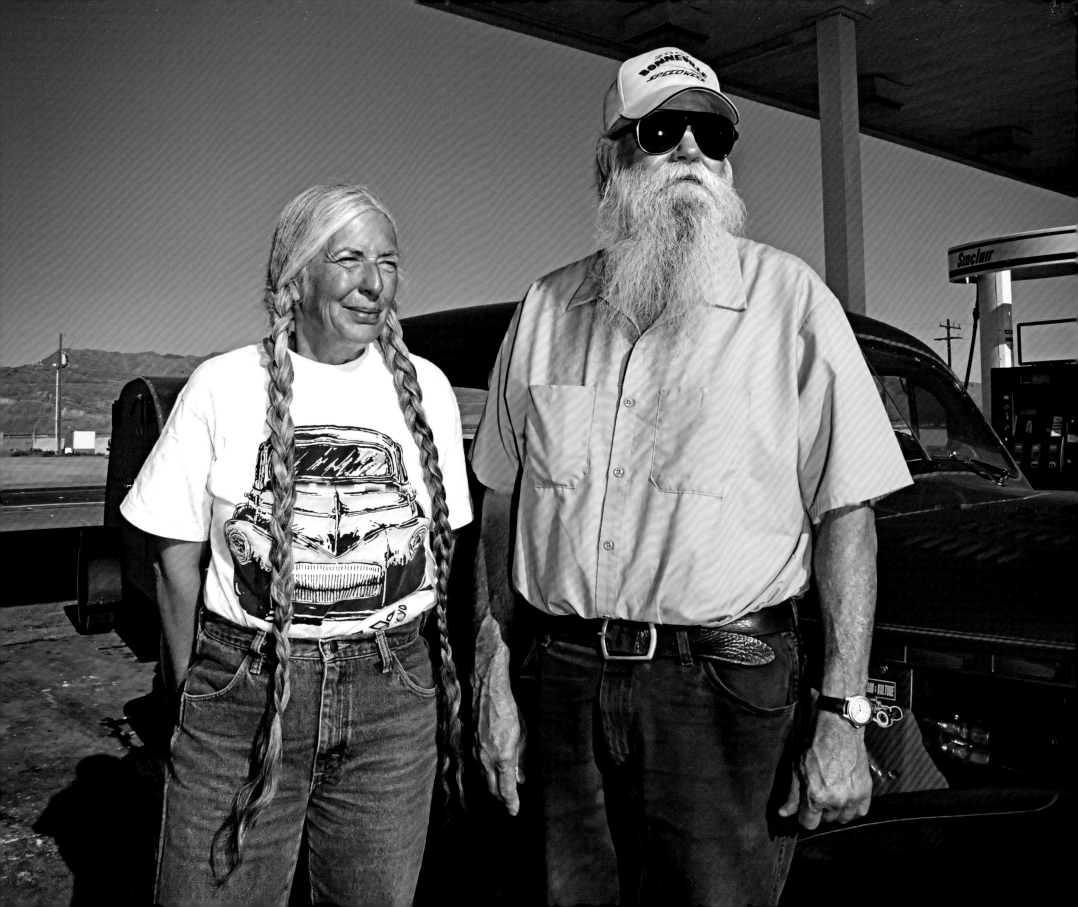

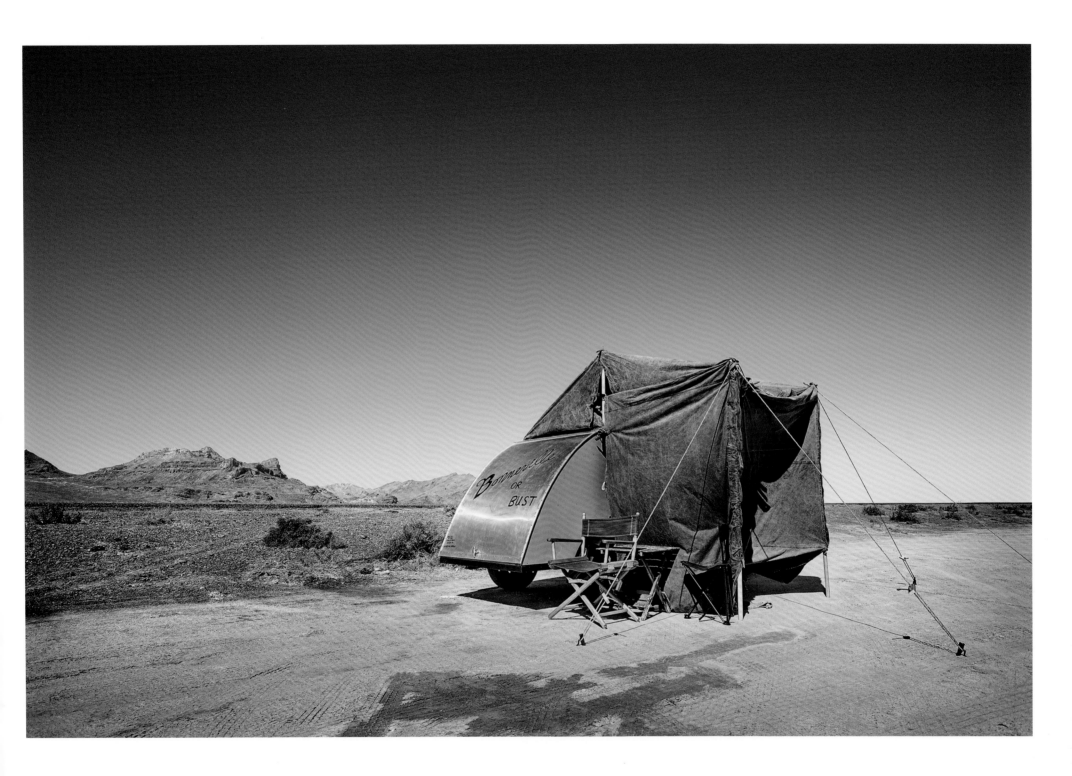

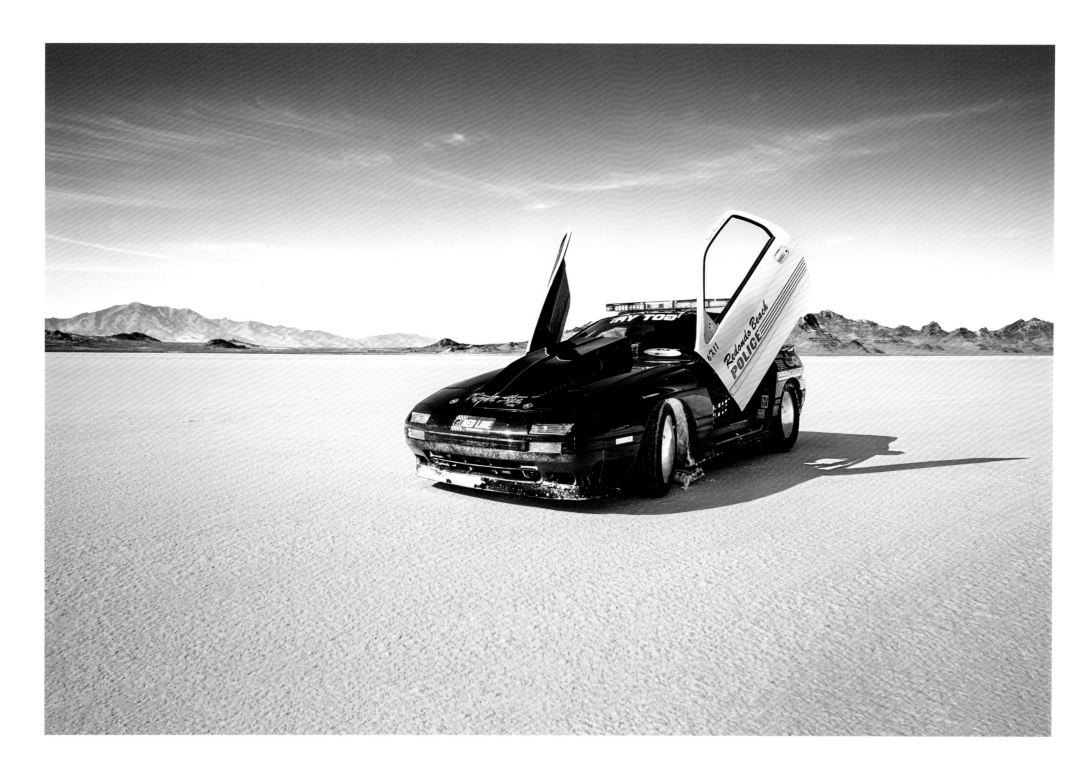

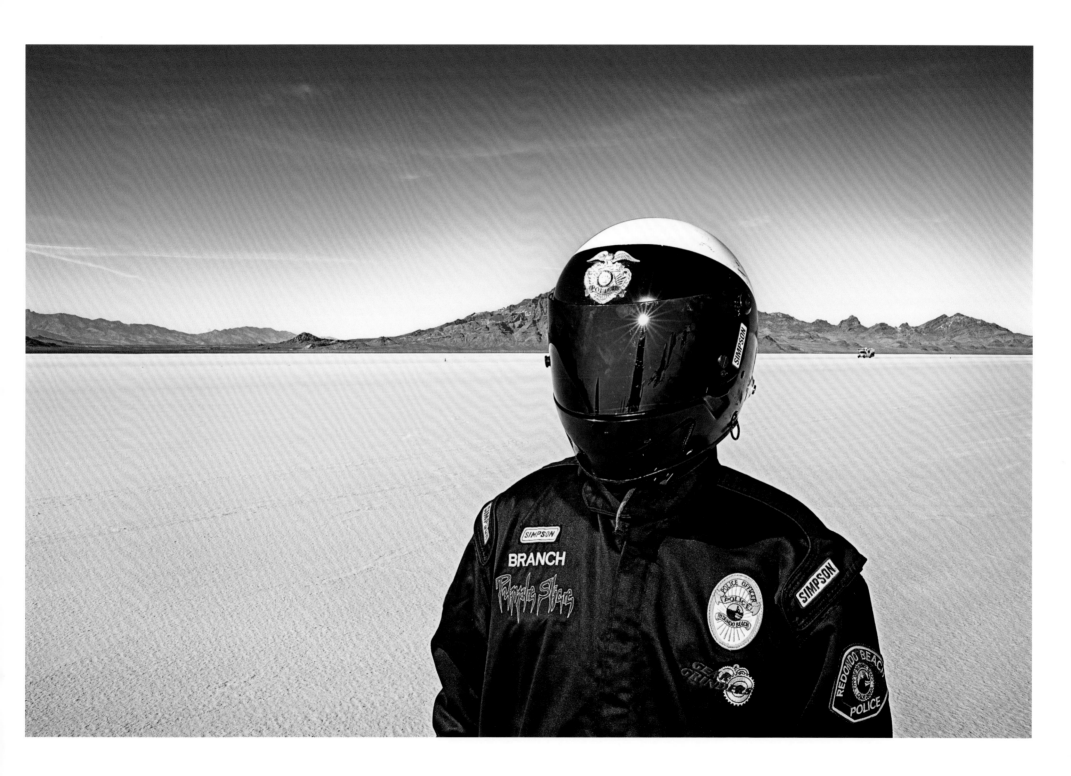

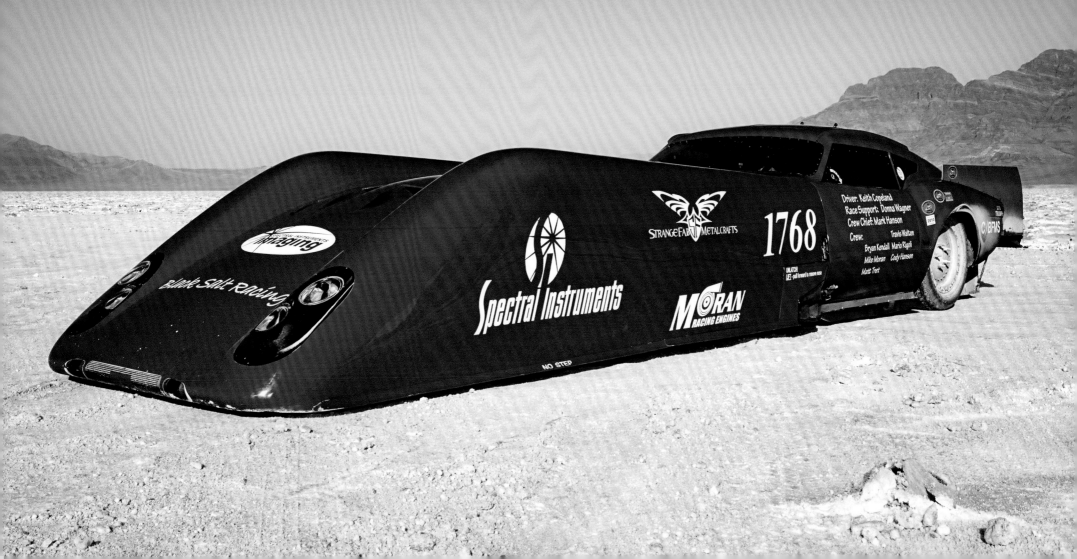

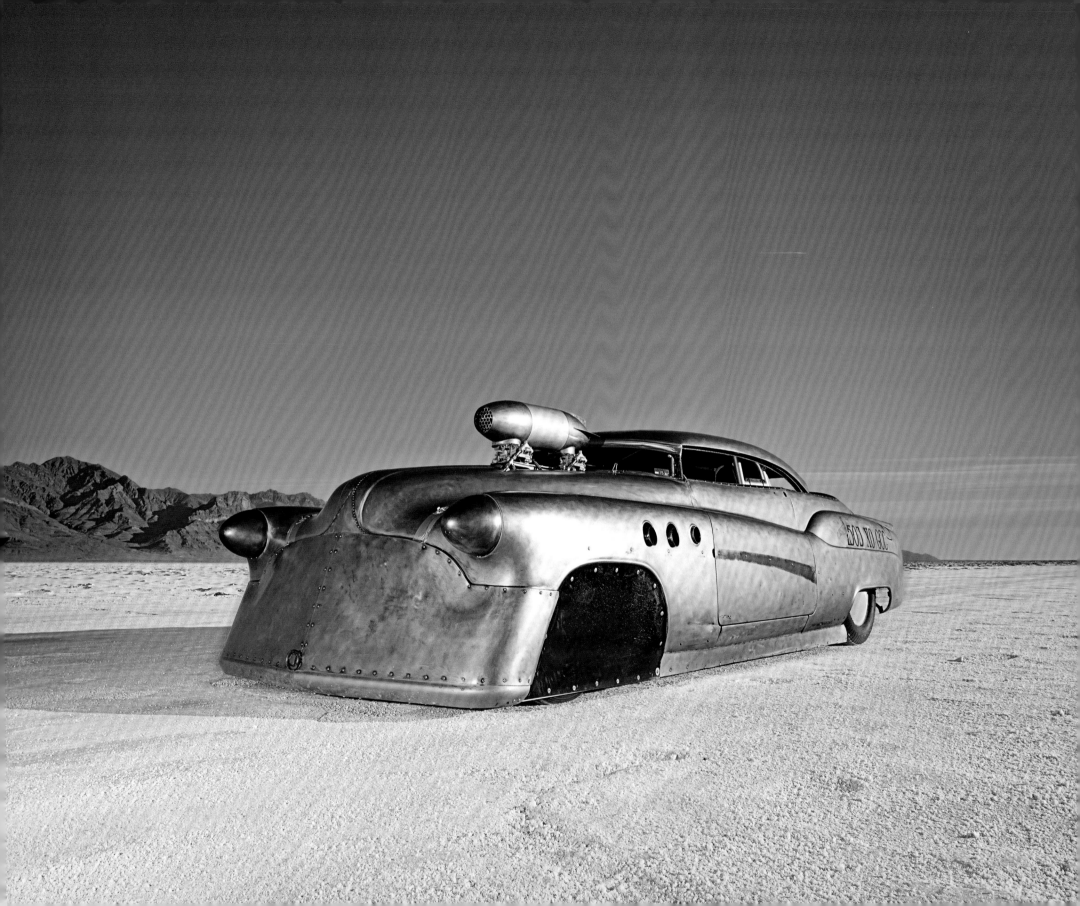

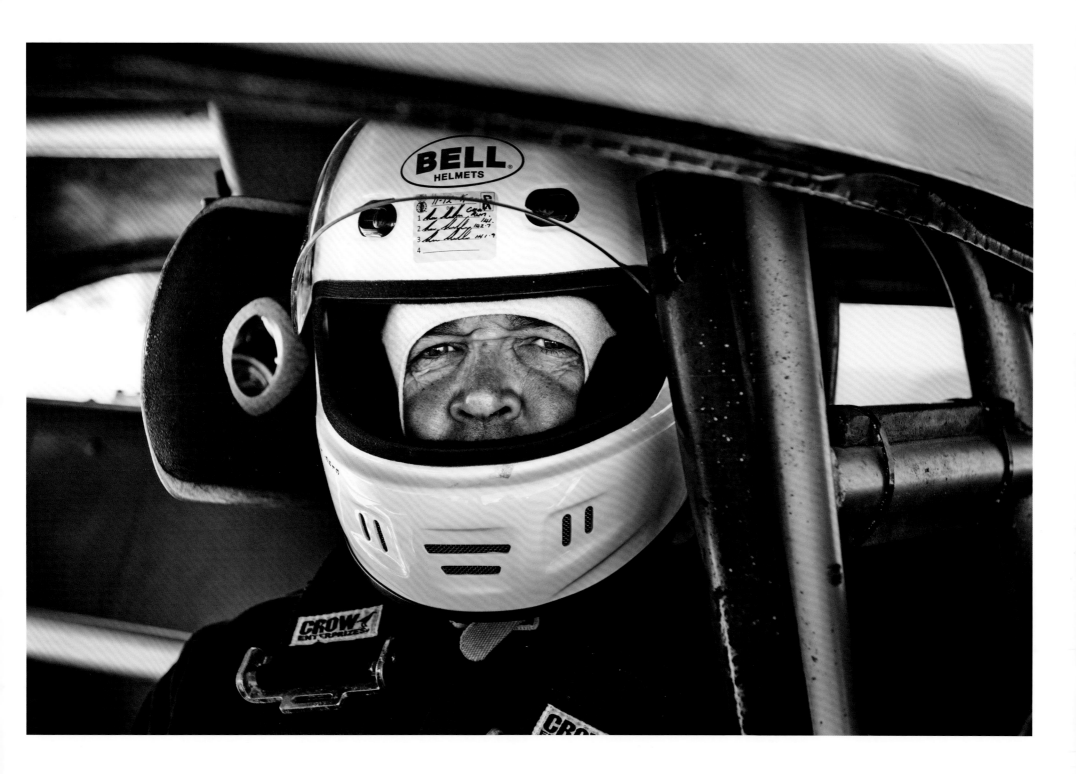

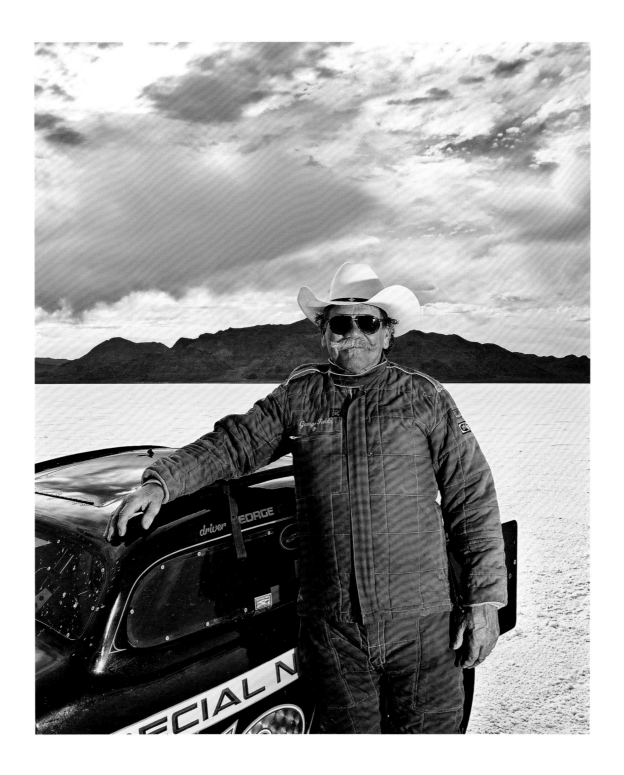

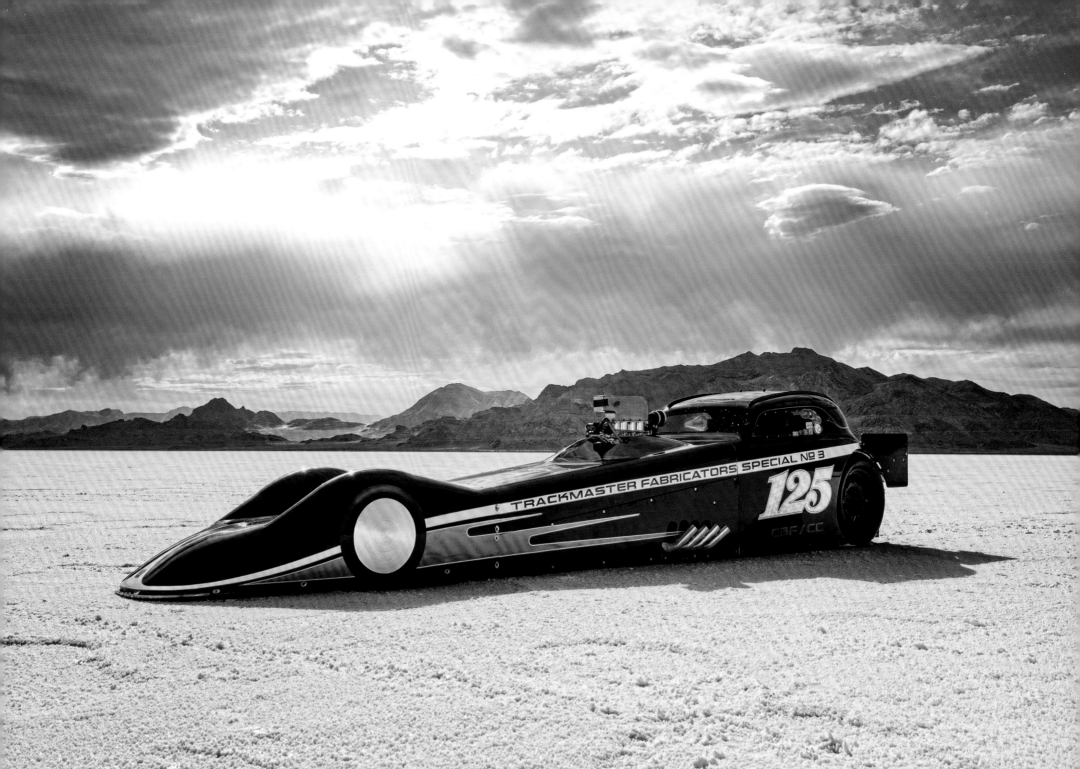

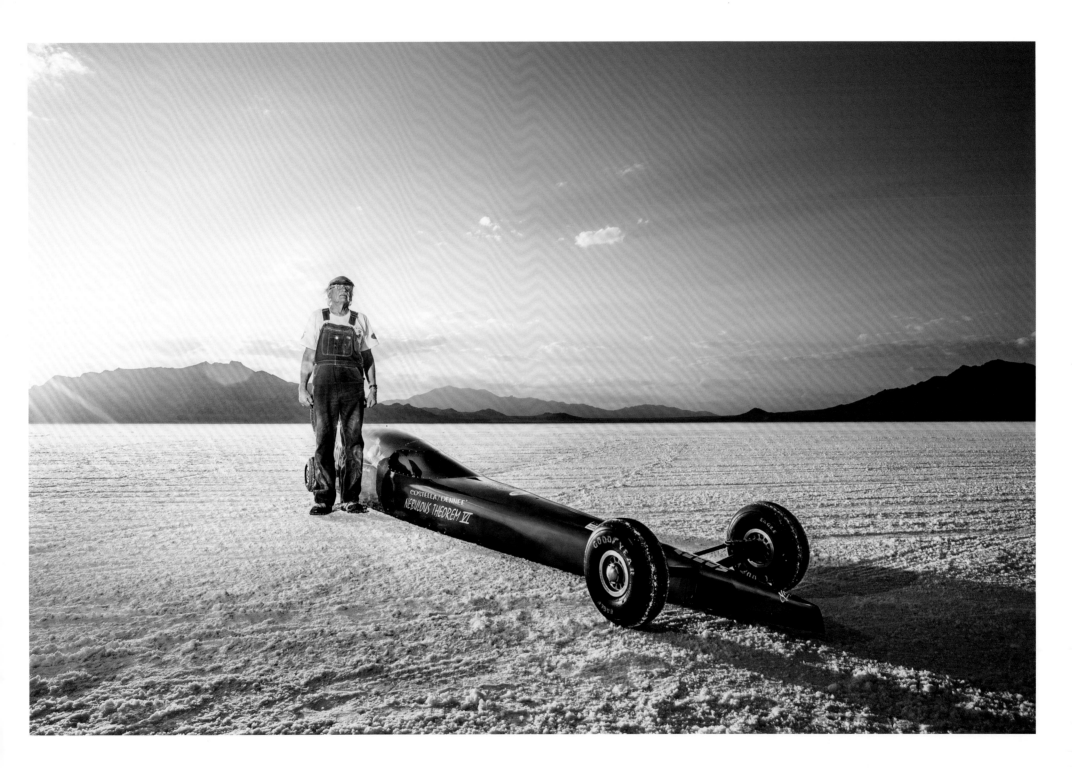

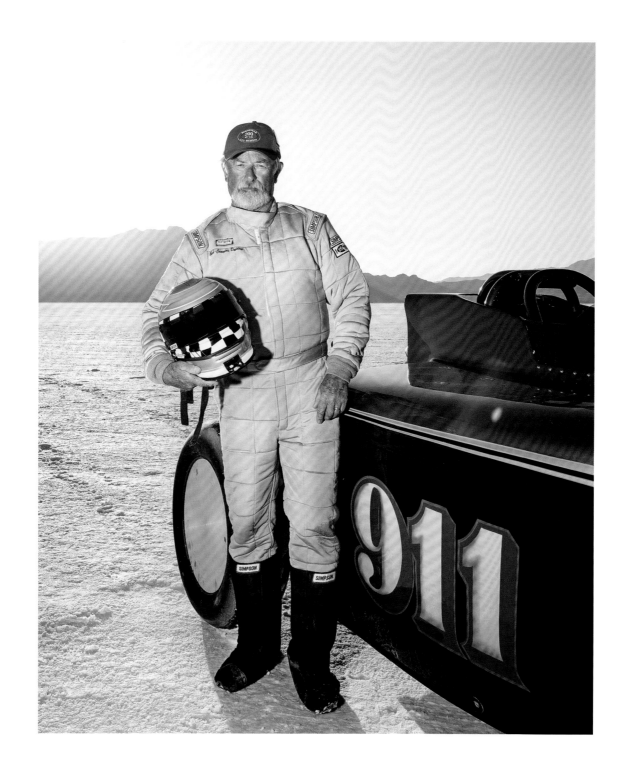

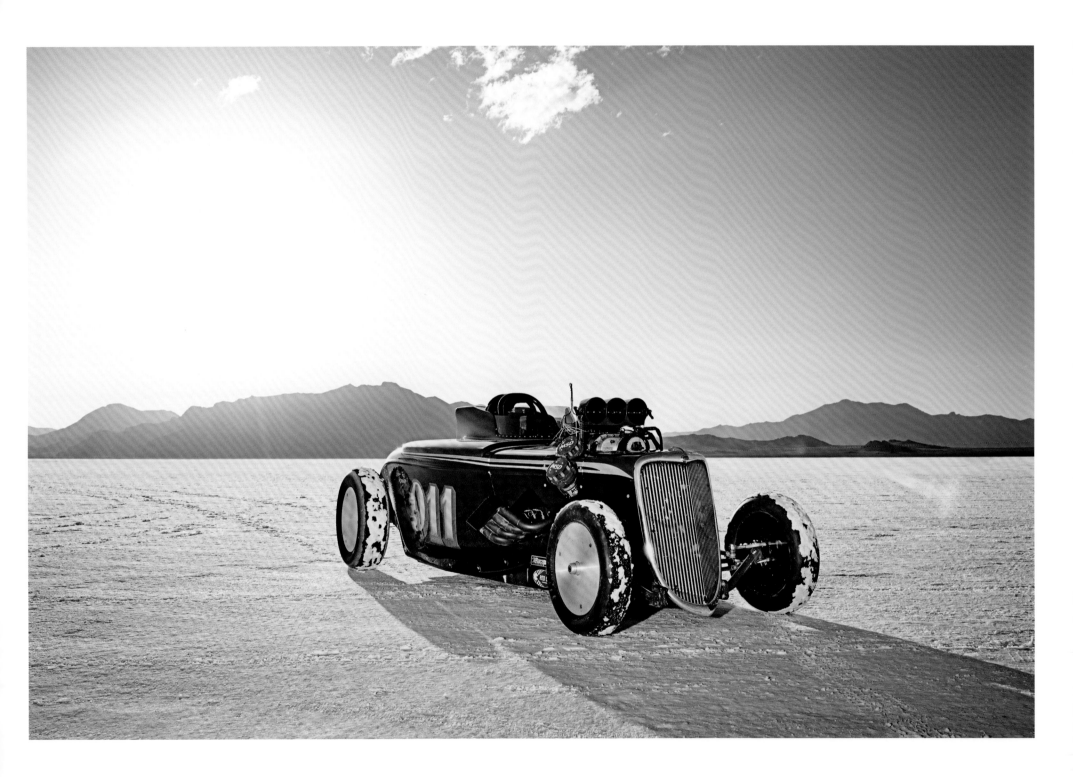

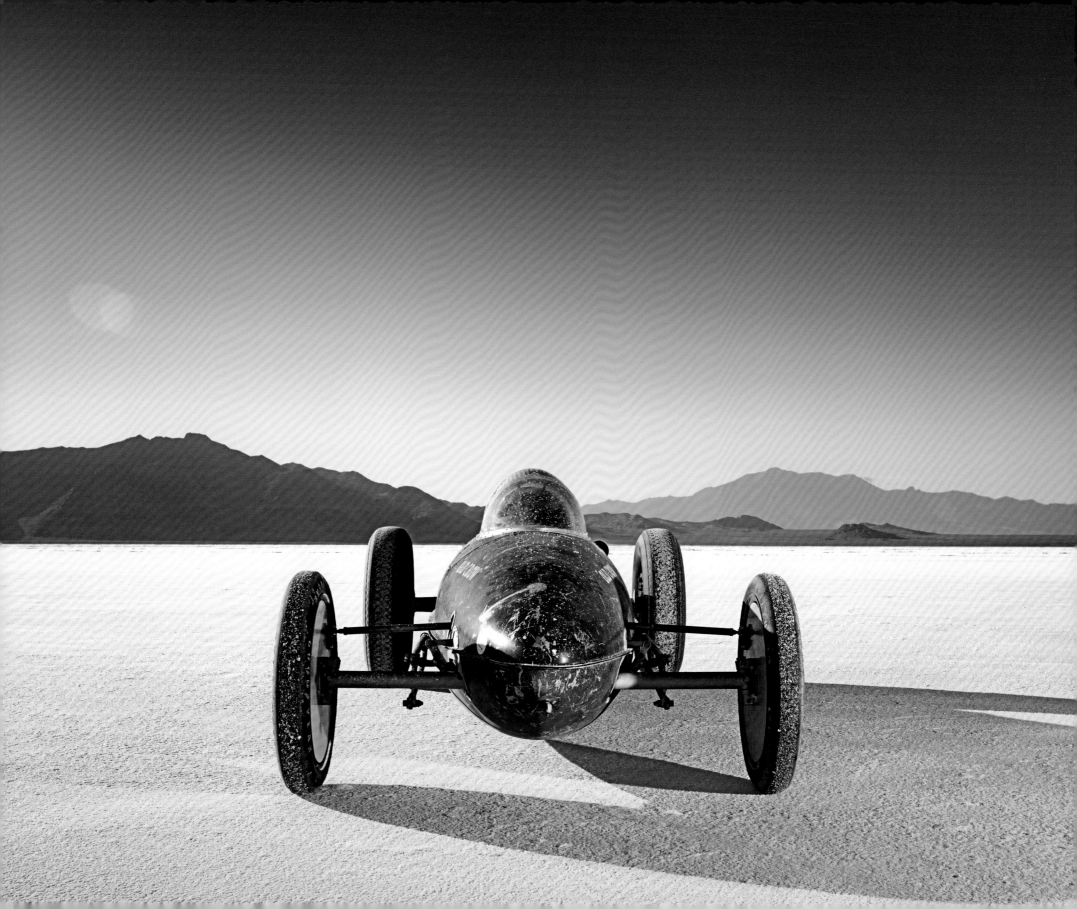

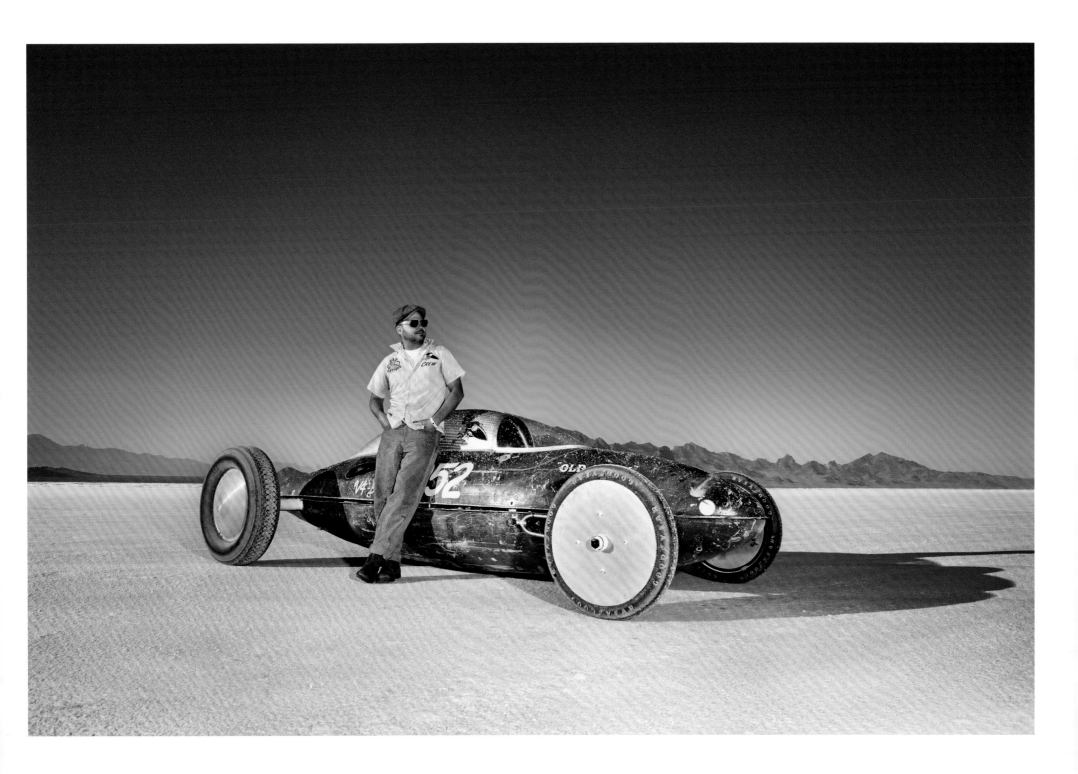

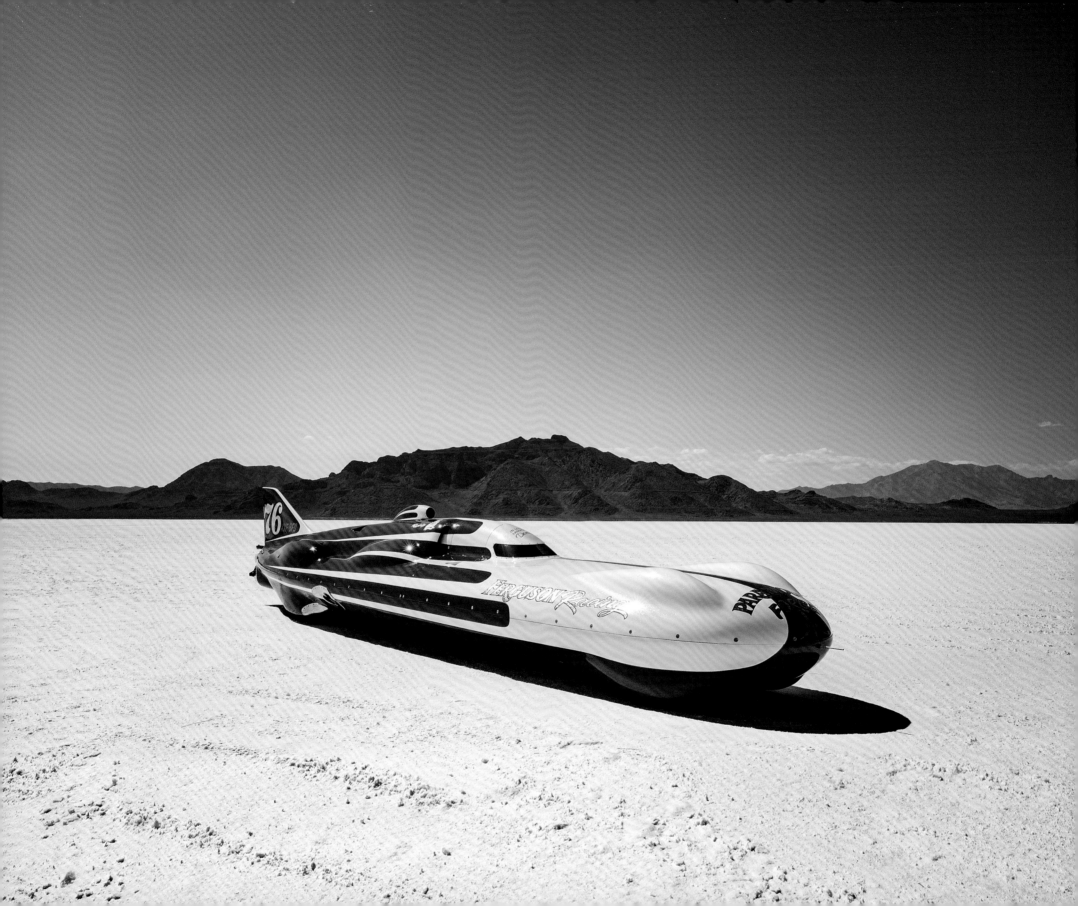

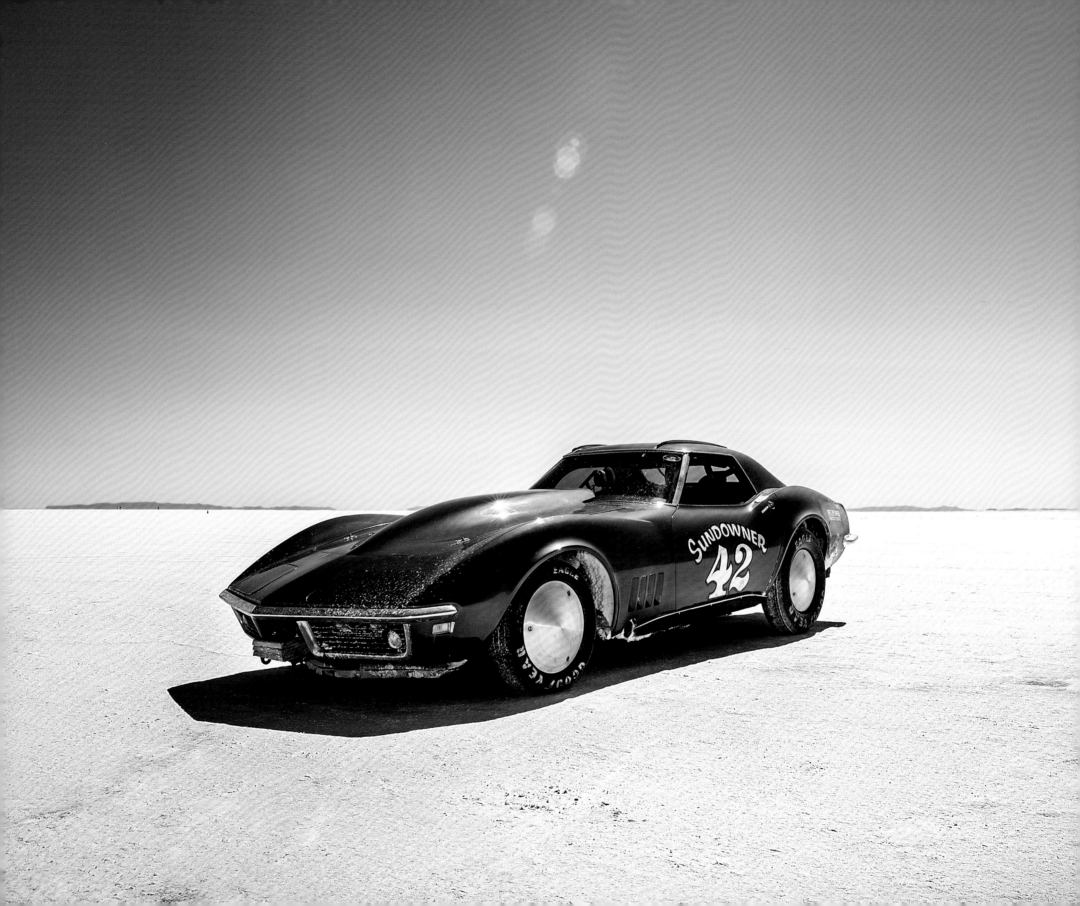

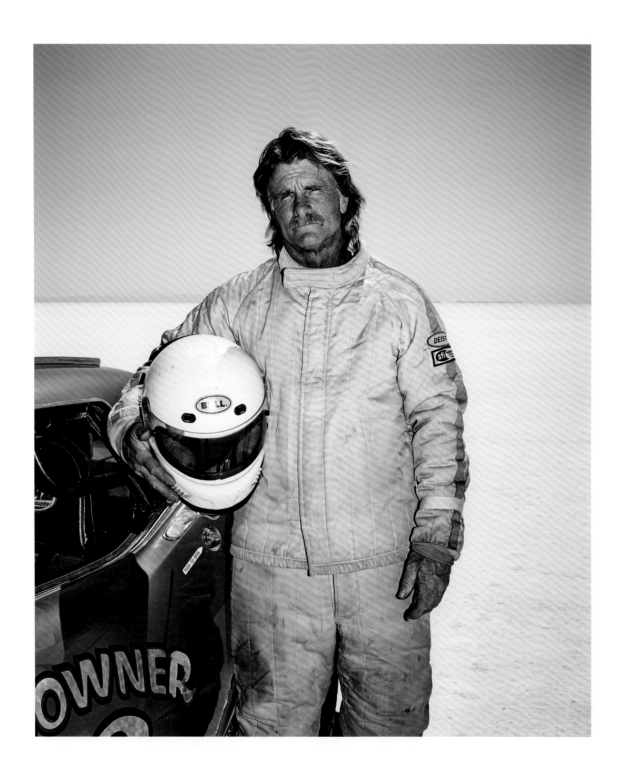

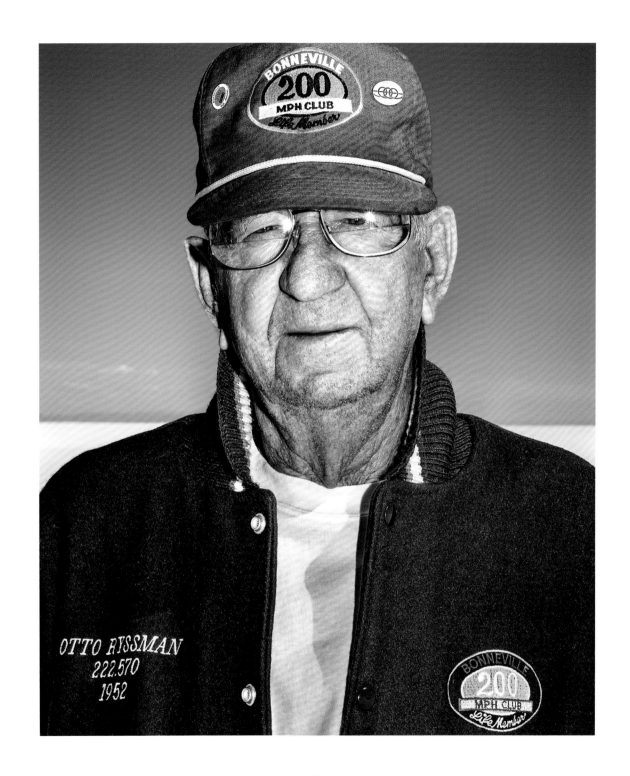

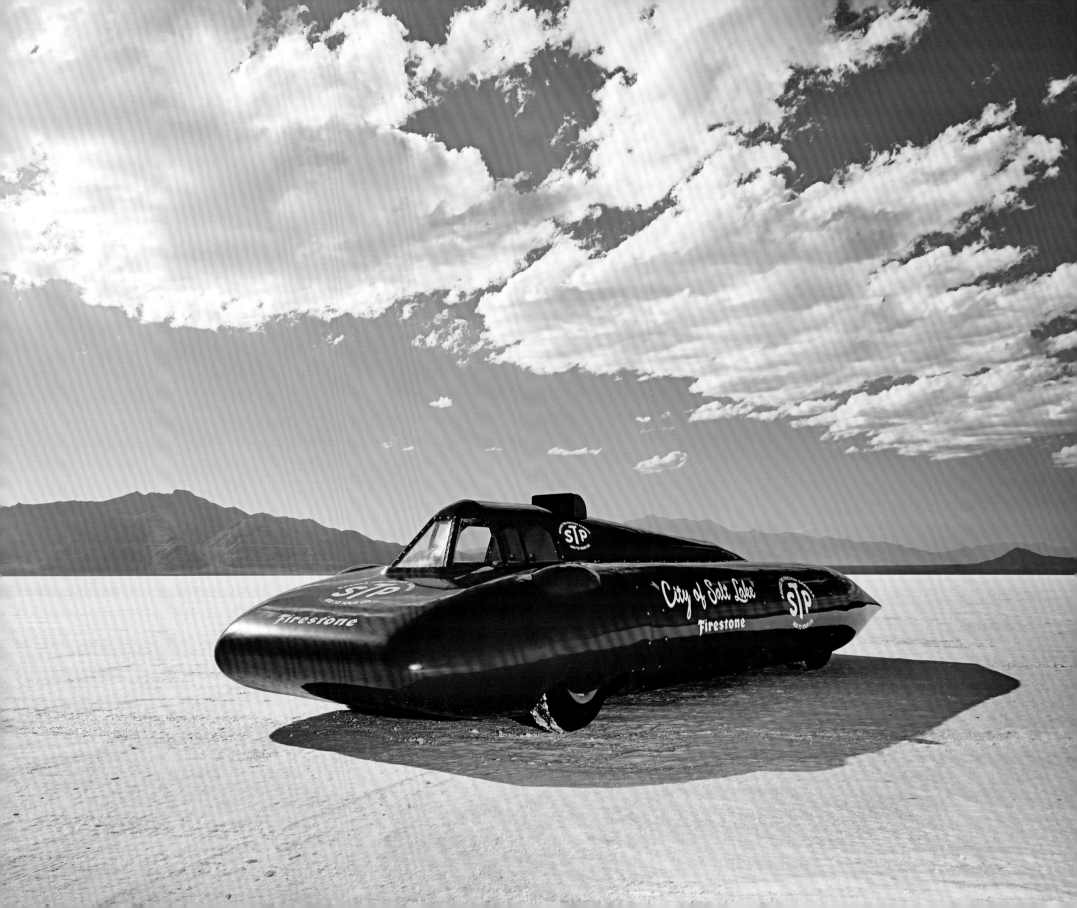

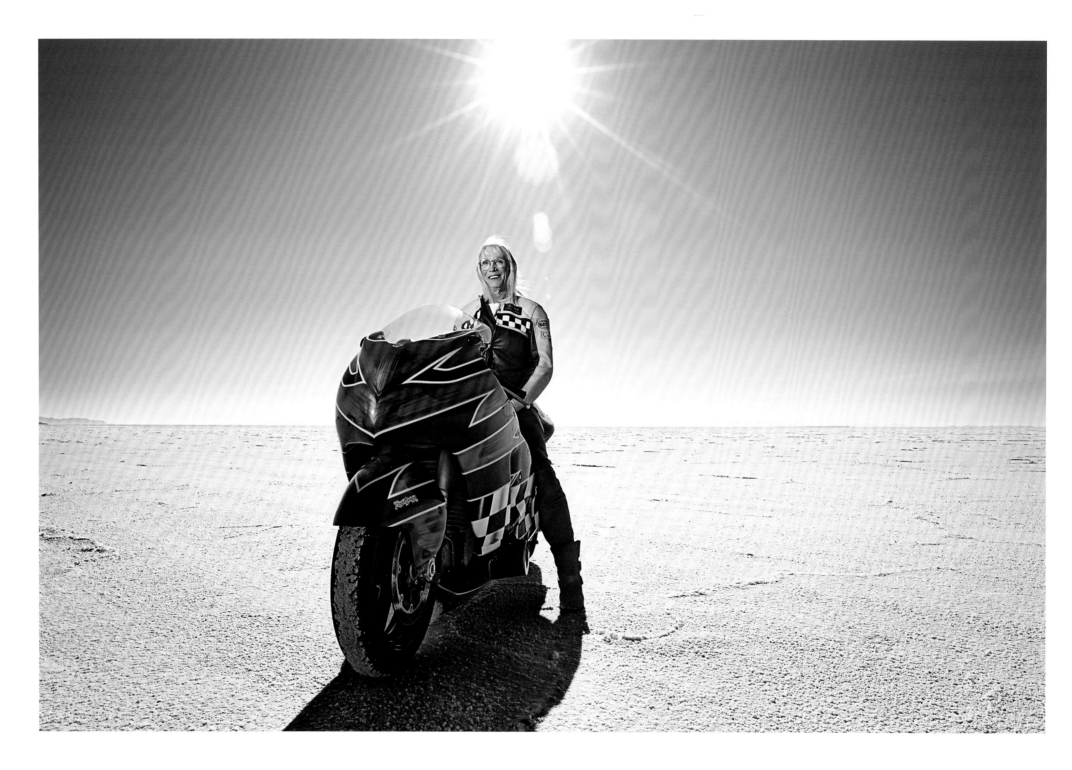

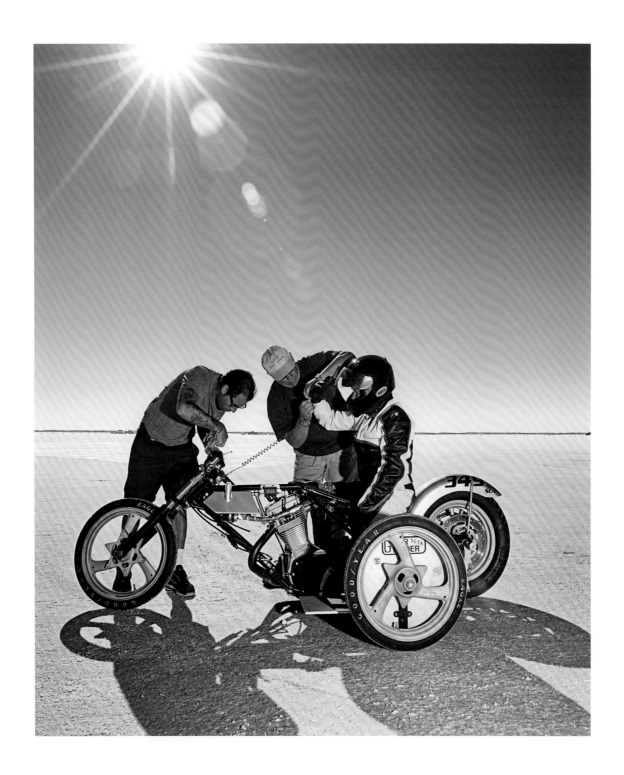

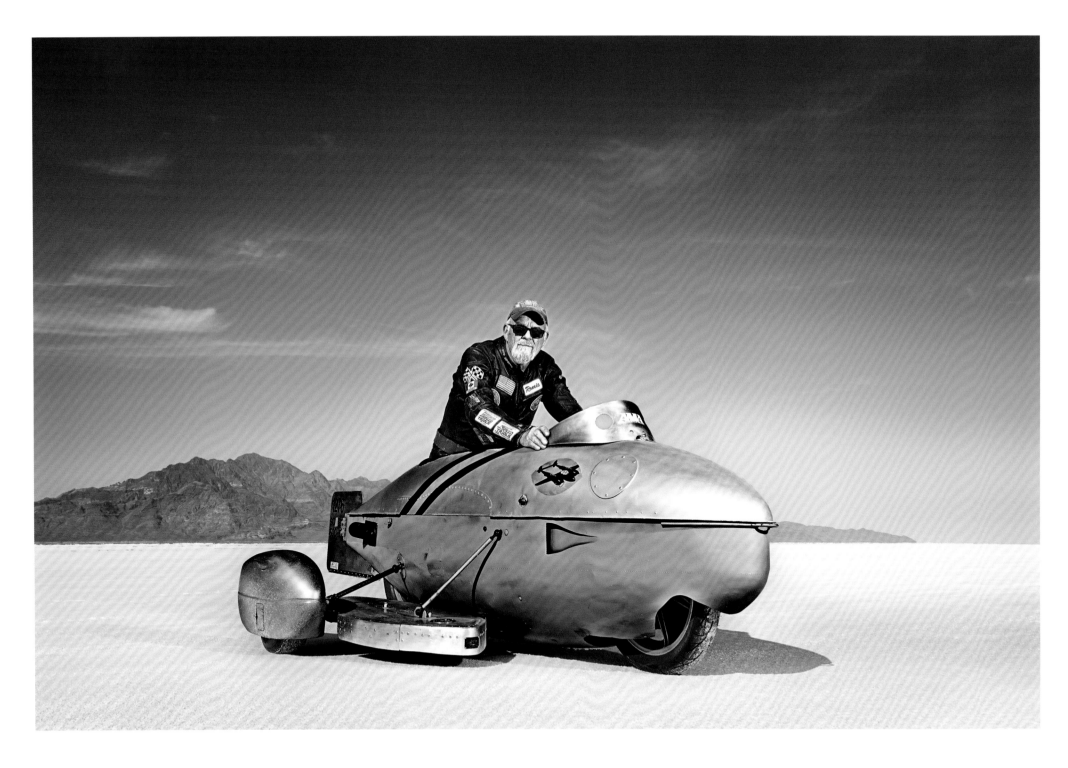

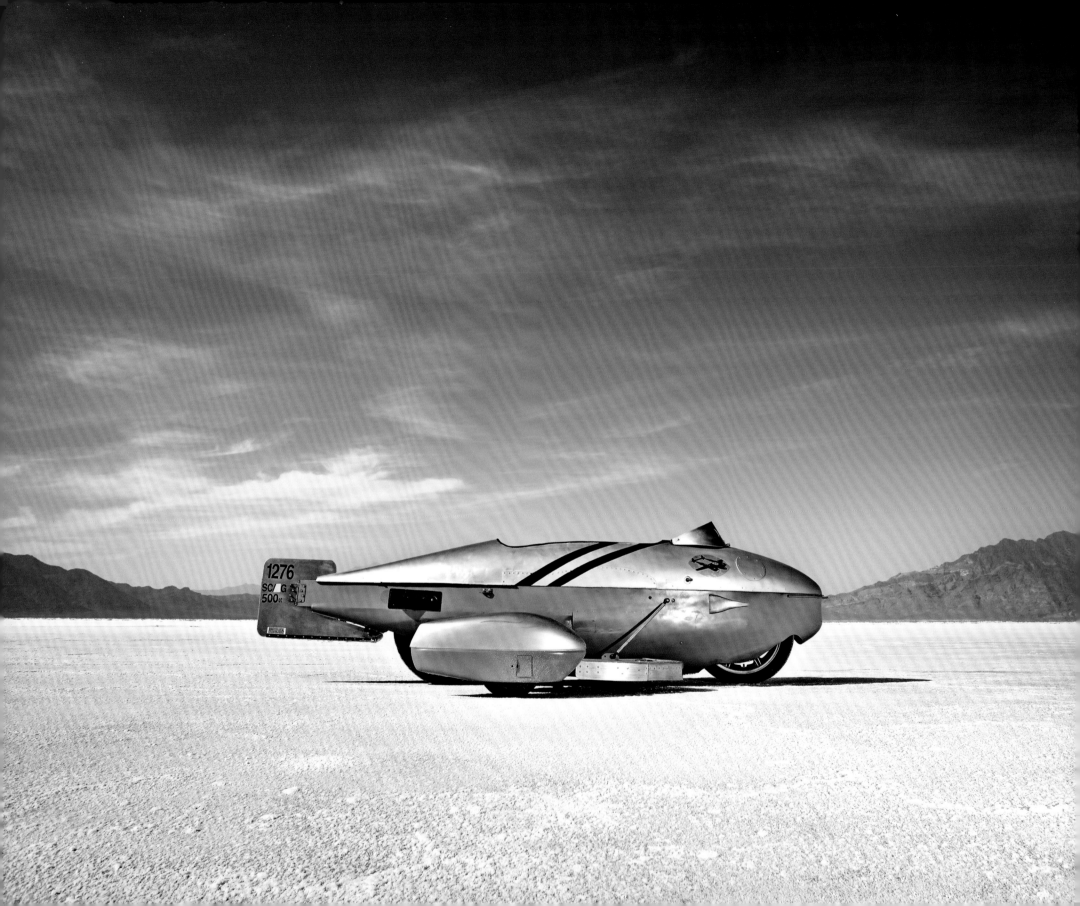

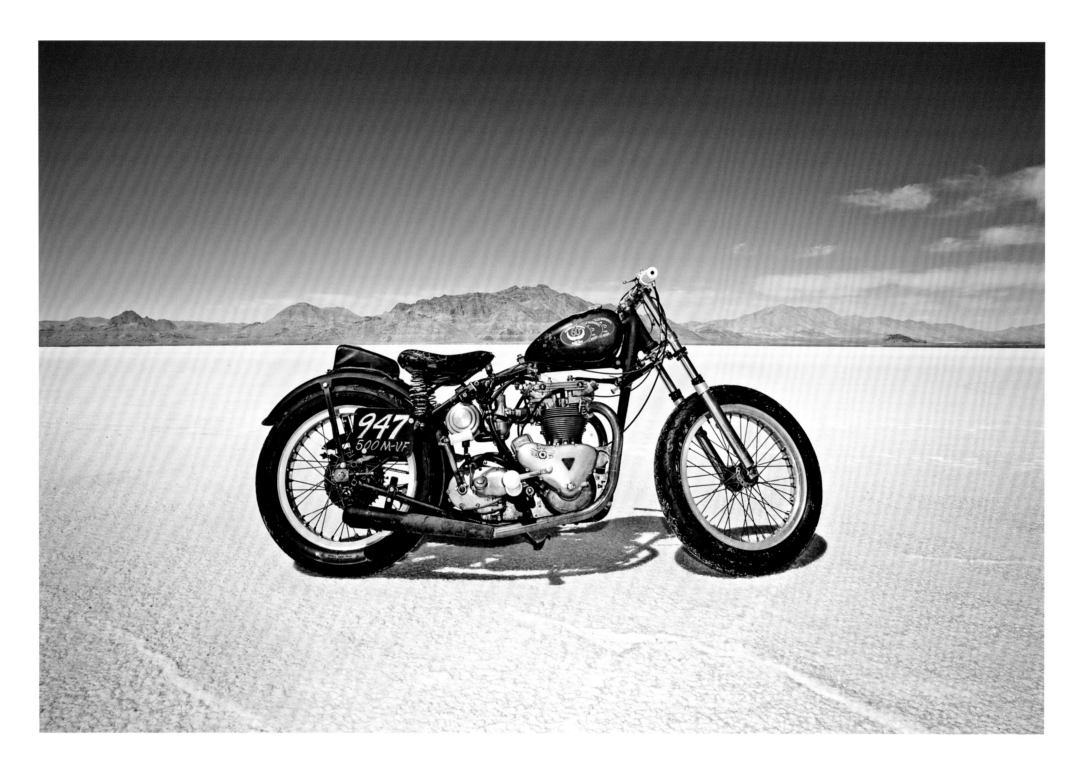

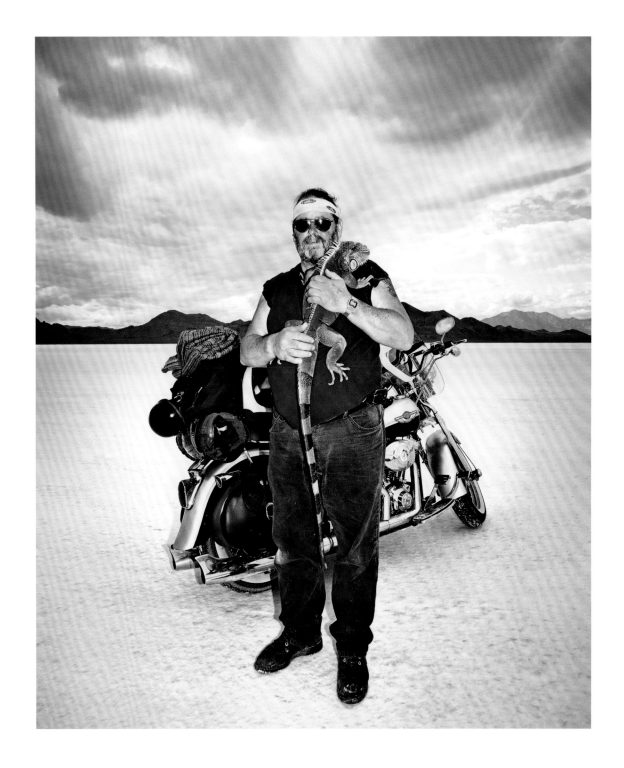

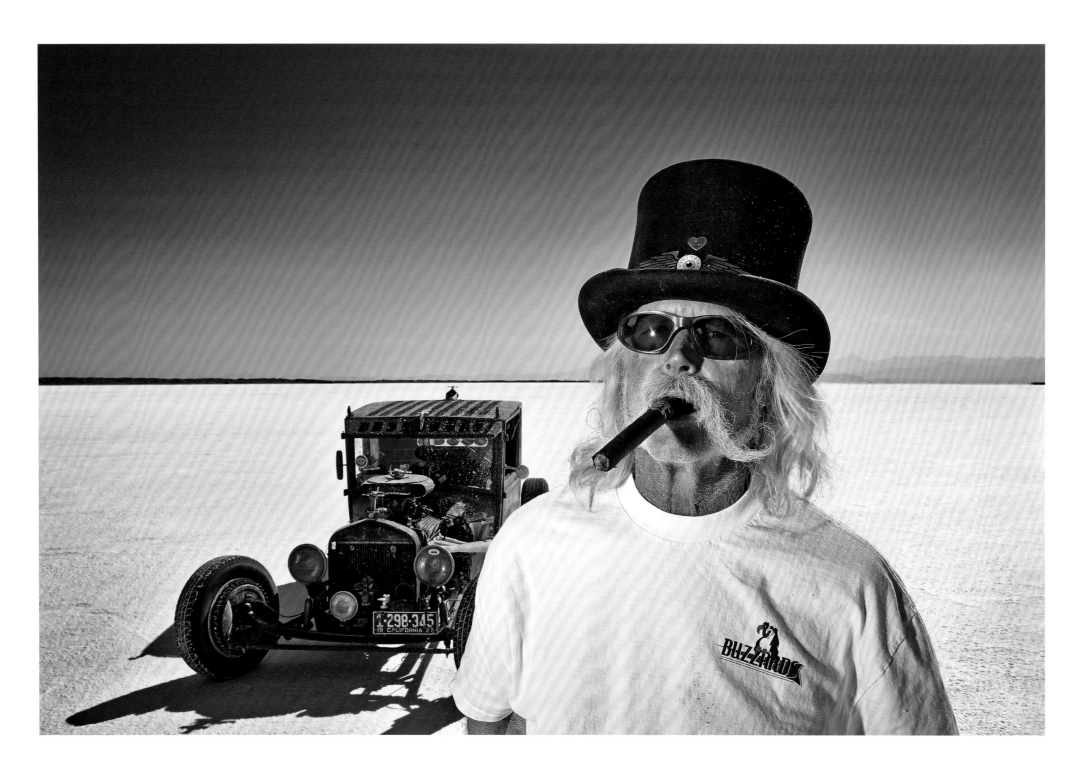

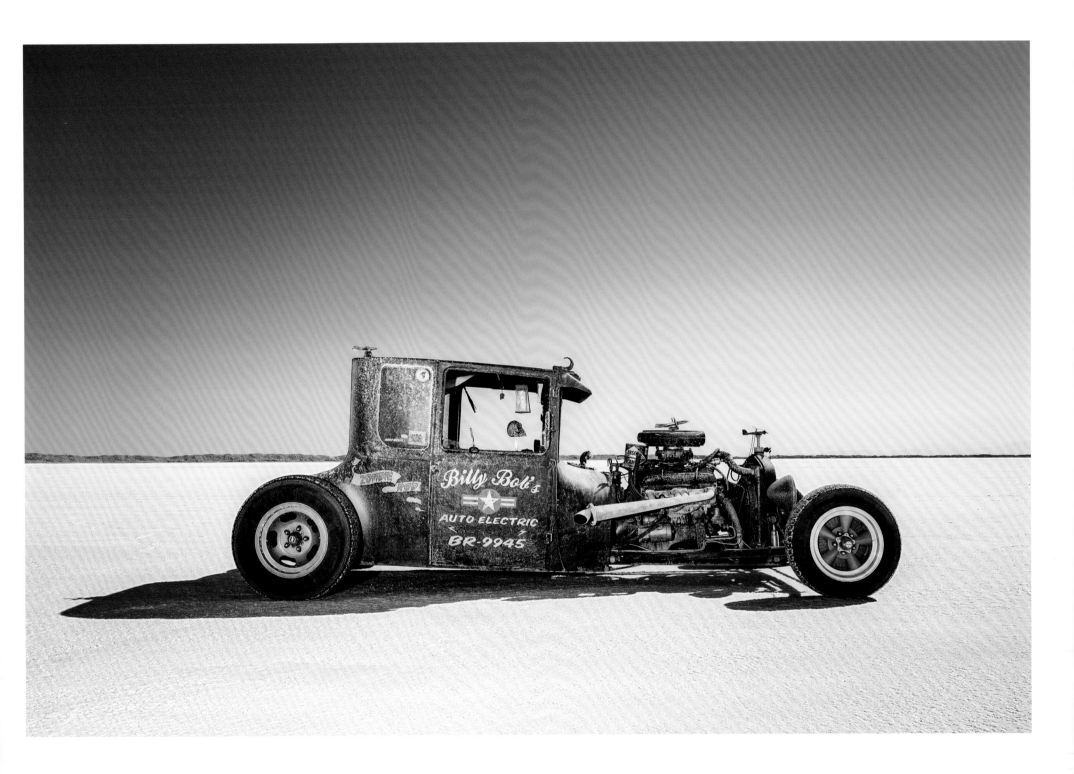

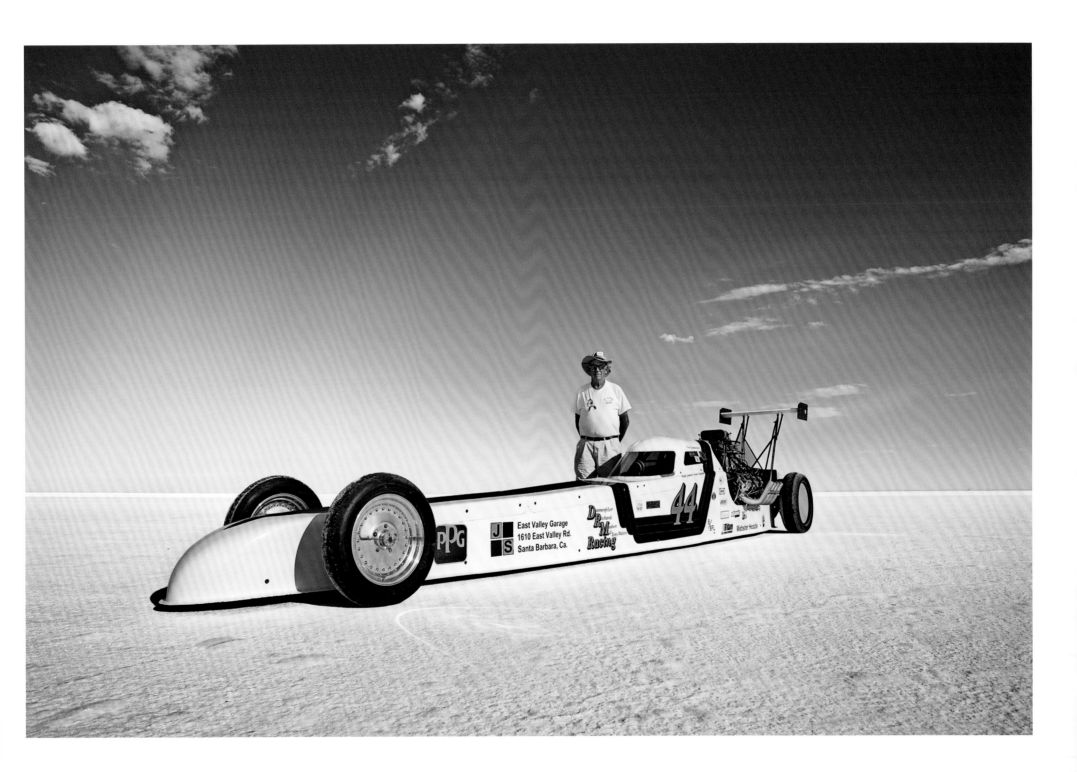

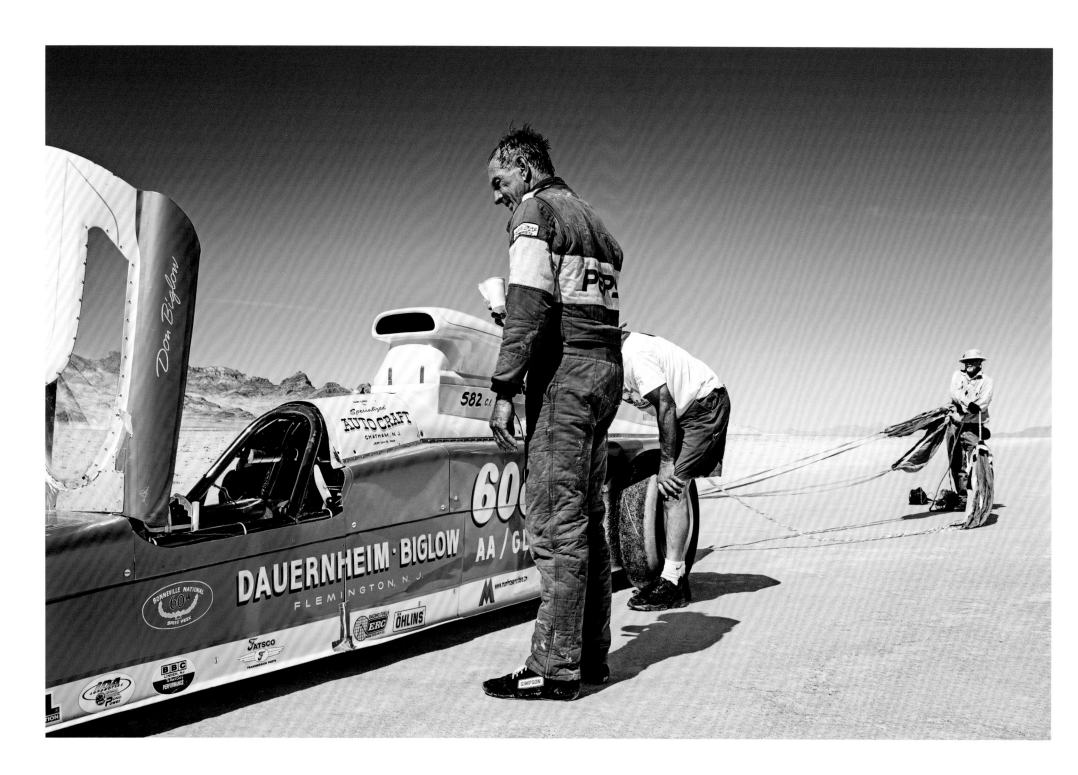

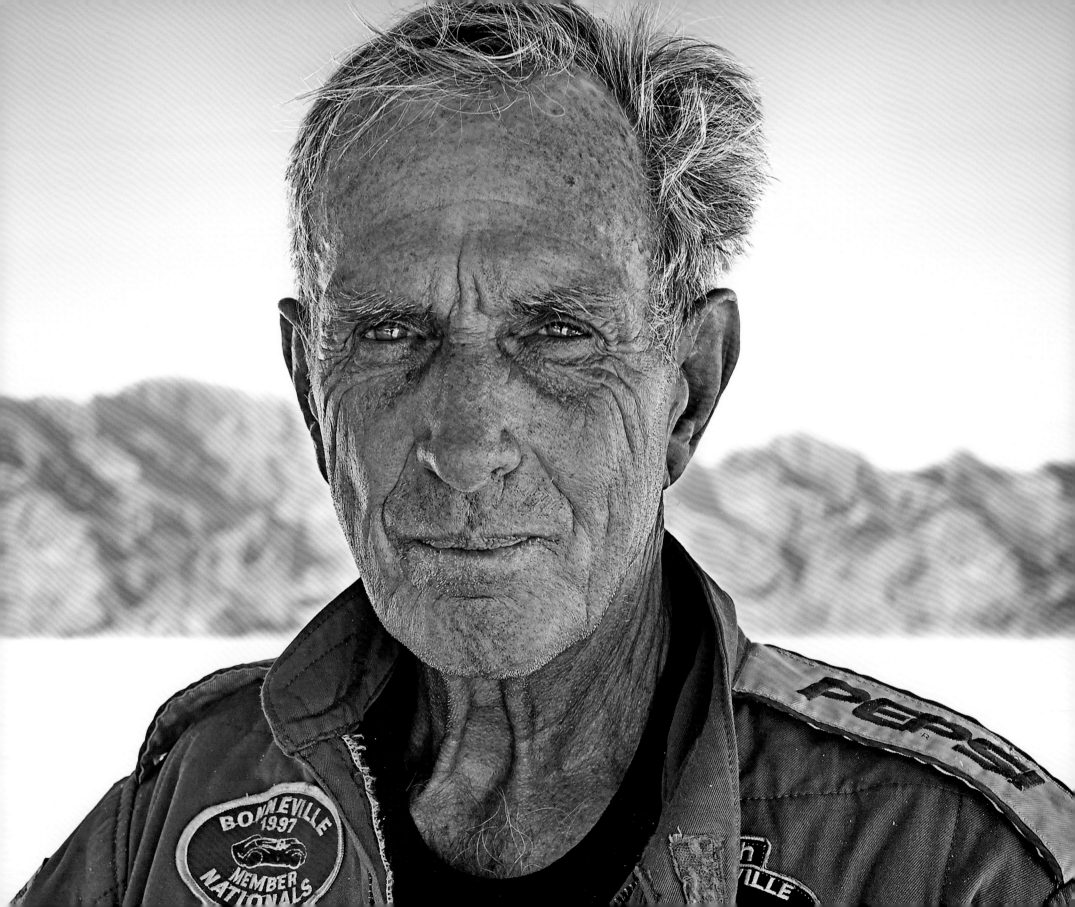

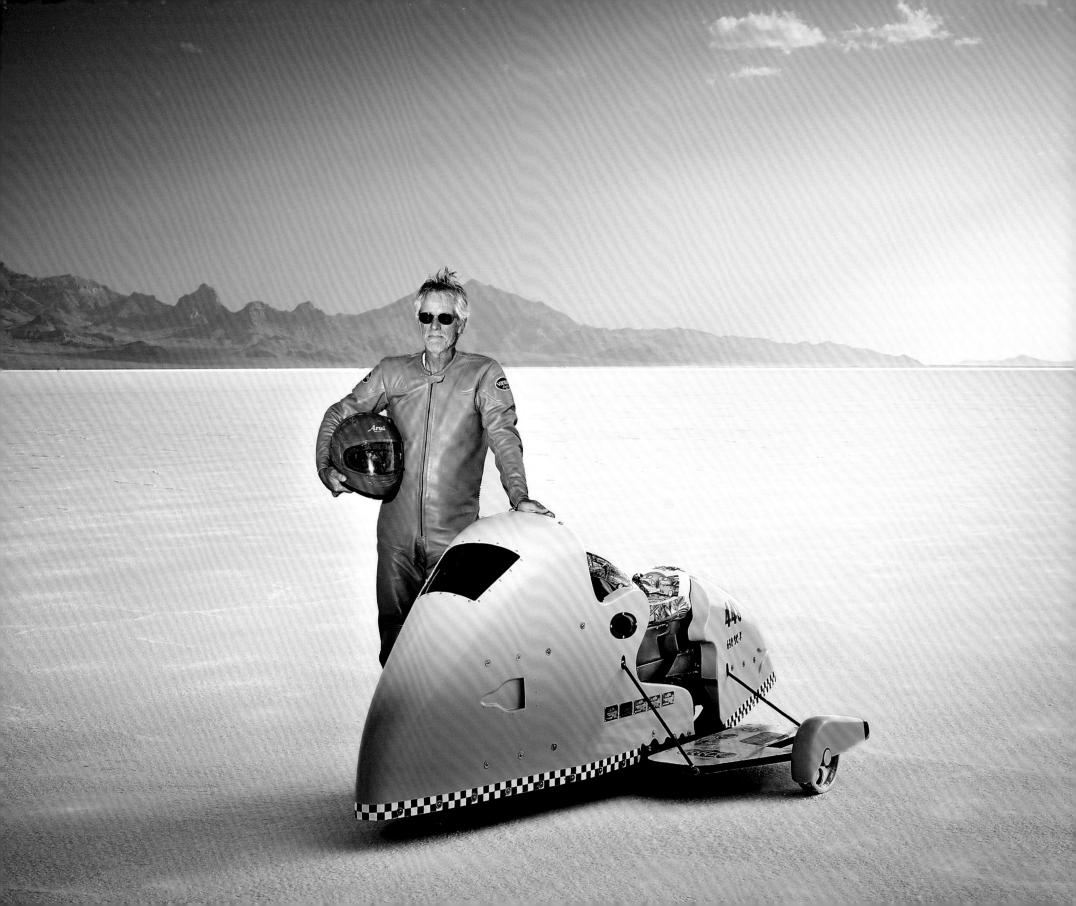

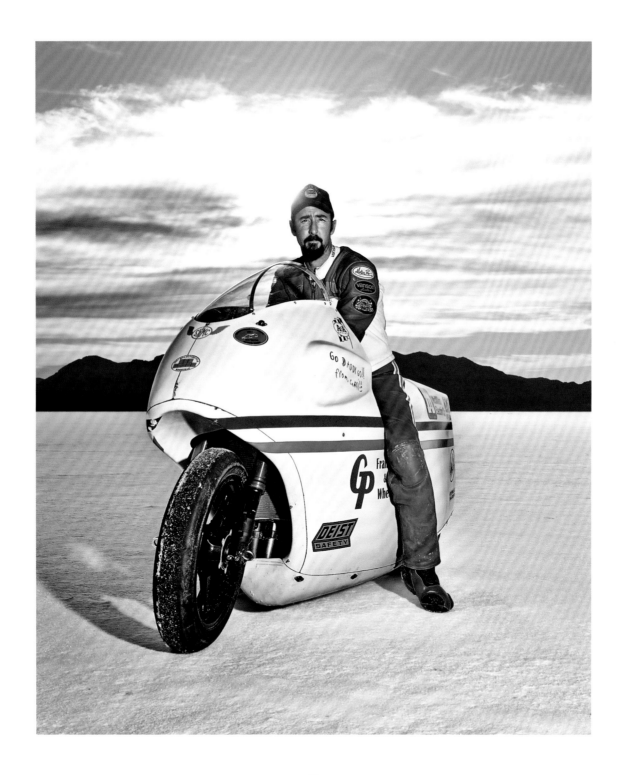

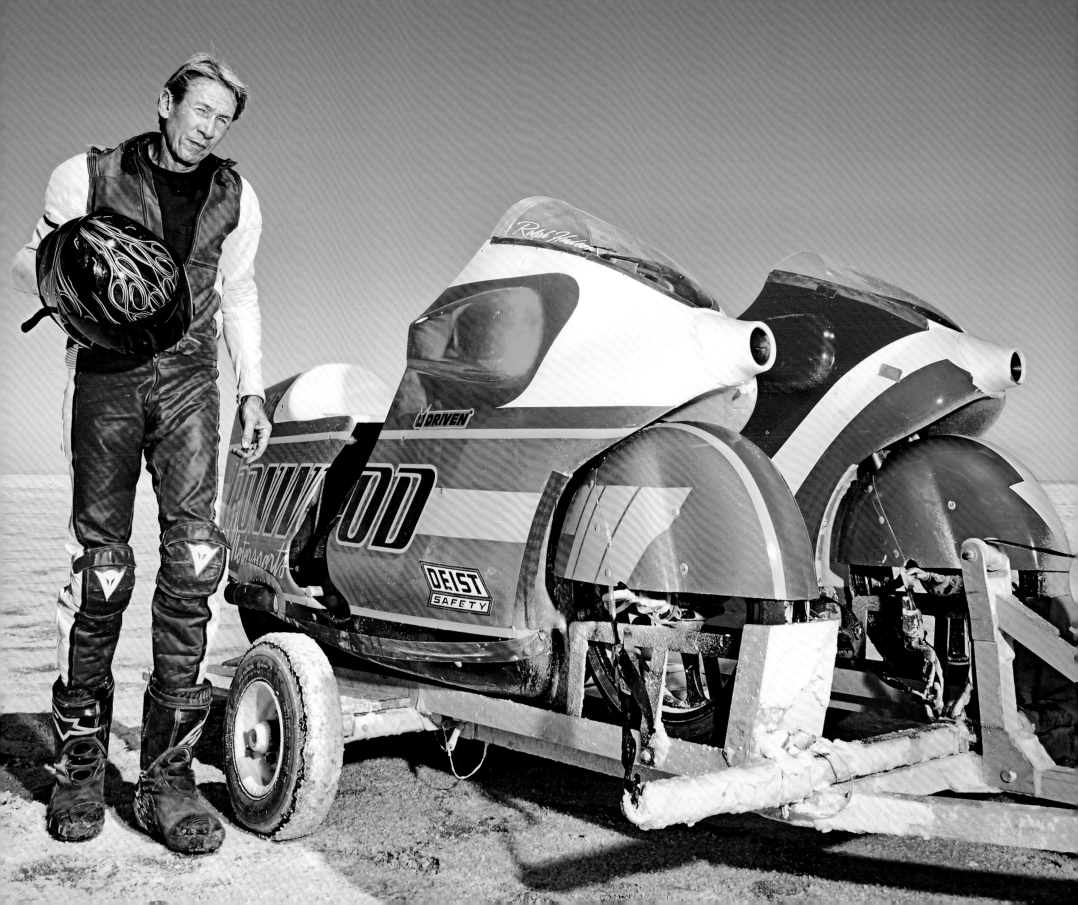

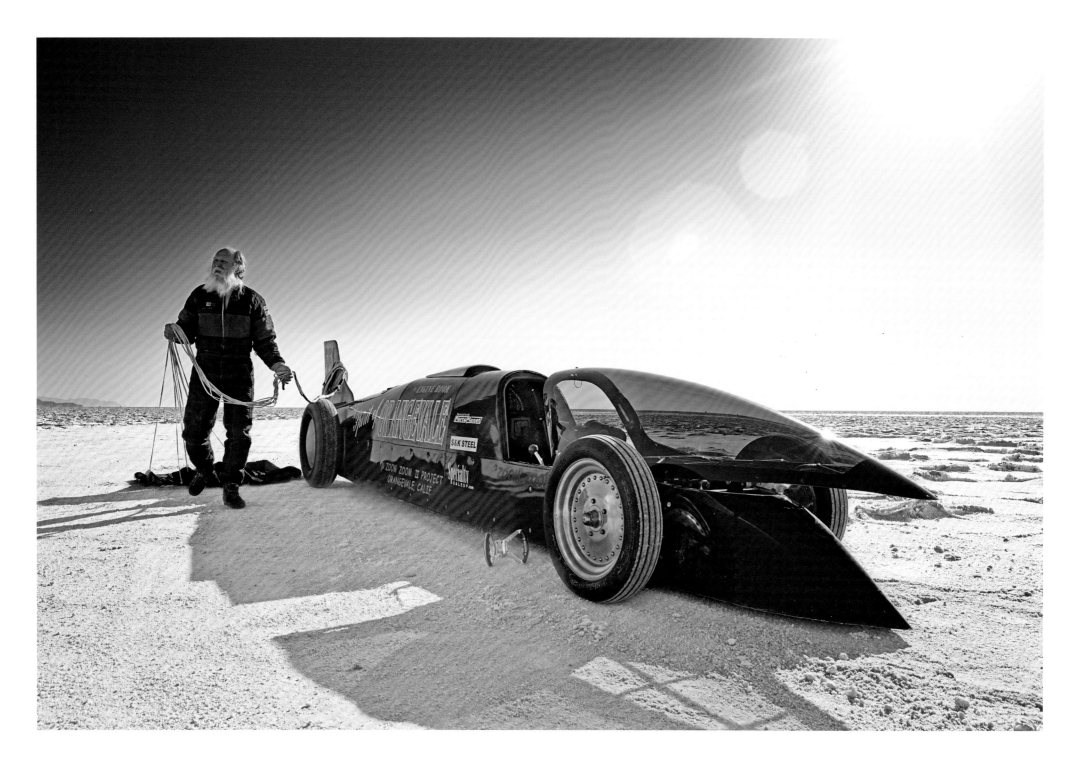

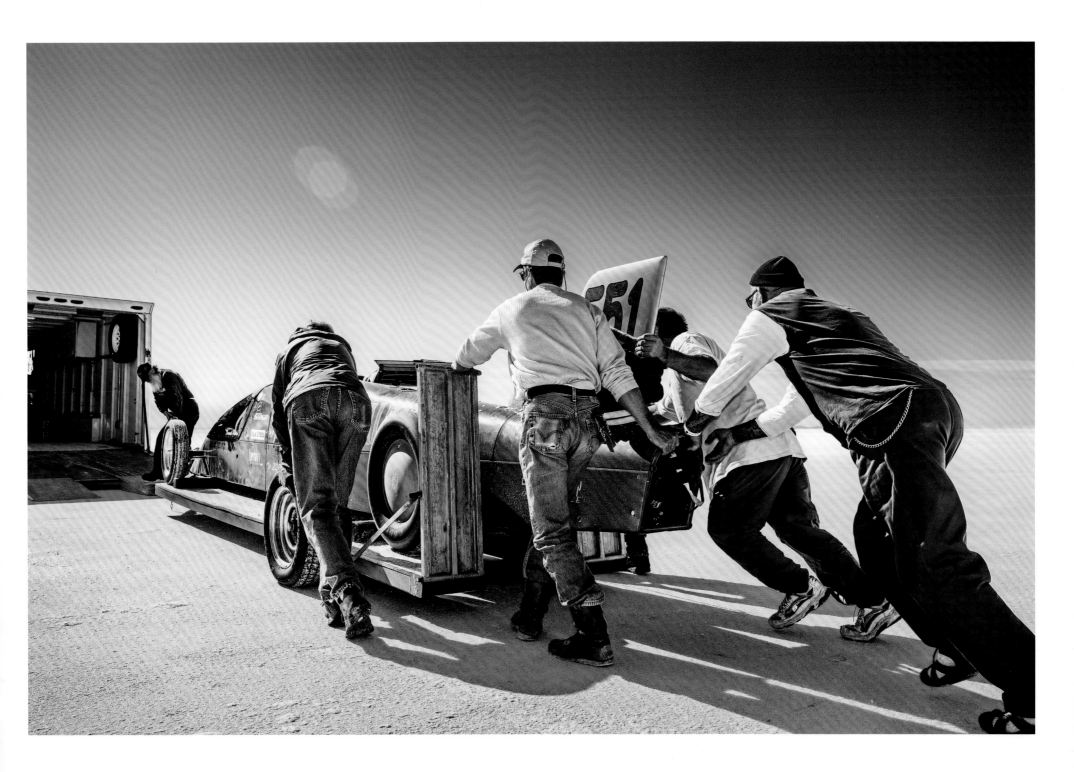

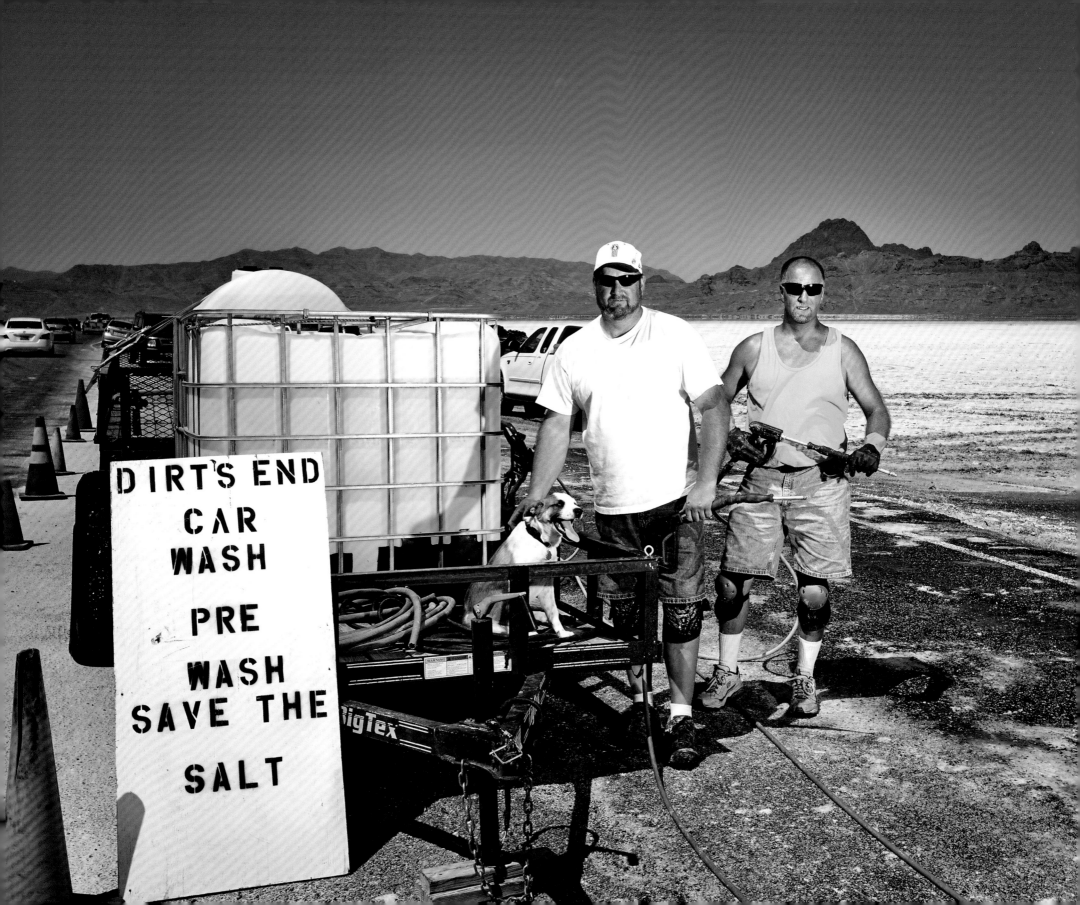

GARAGE

There is a real beauty in every garage or shop. Every manner of shop-keeping is to be found. There are the pack rats, the pilers, the filers, and the ones who are magicians creating wondrous things out of seemingly barren shops. These traits cross all economic, class, age, and racial lines because now we are getting a glimpse into an individual, a fellow human being, another "one." Every shop is a distillation of its inhabitant and the community formed there.

The garage of a land speed racer is where record holders and their challengers are built by hand. Most land speed shops are also complete fabrication facilities where the parts, chassis, and body panels are all made in-house. When a shop closes for good, the knowledge it contained spreads out. Manuals, tools, notebooks, parts, and tips and tricks are passed down, get out into the world and into other hands and brains. In turn, they are passed on again, laterally left and right, up and down, backwards and forwards.

Shed, studio, shop, and maybe, but not necessarily, a "man cave": The garage can be imbued with one or all of these meanings. When one is obsessed to the "I gotta have it!" point with any endeavor, a sanctuary is needed to channel the obsession into meaningful directions. A place is needed to store the means to the ends, to keep a library, to make a mess of things, to tidy aimlessly while shuffling ideas, to share secrets and stories, to be uncensored, unfiltered, to get things done. For the land speed racer, the garage is that place.

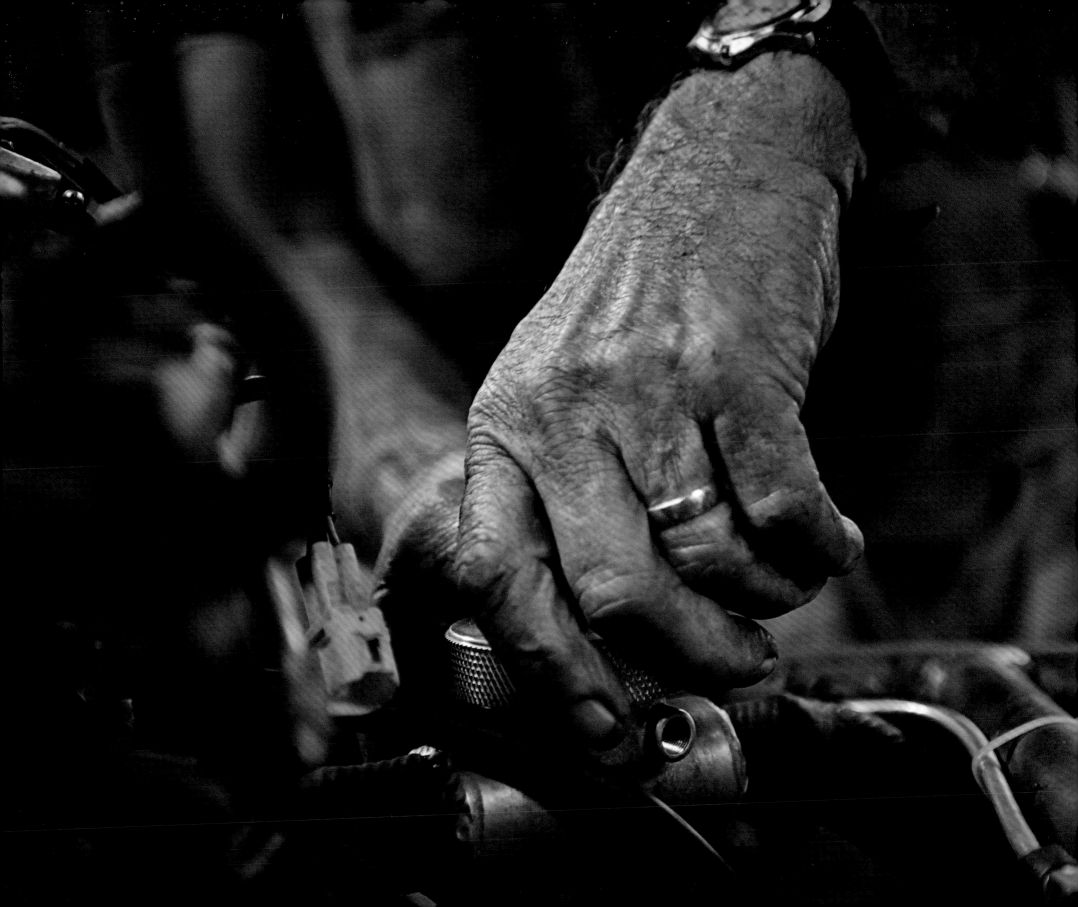

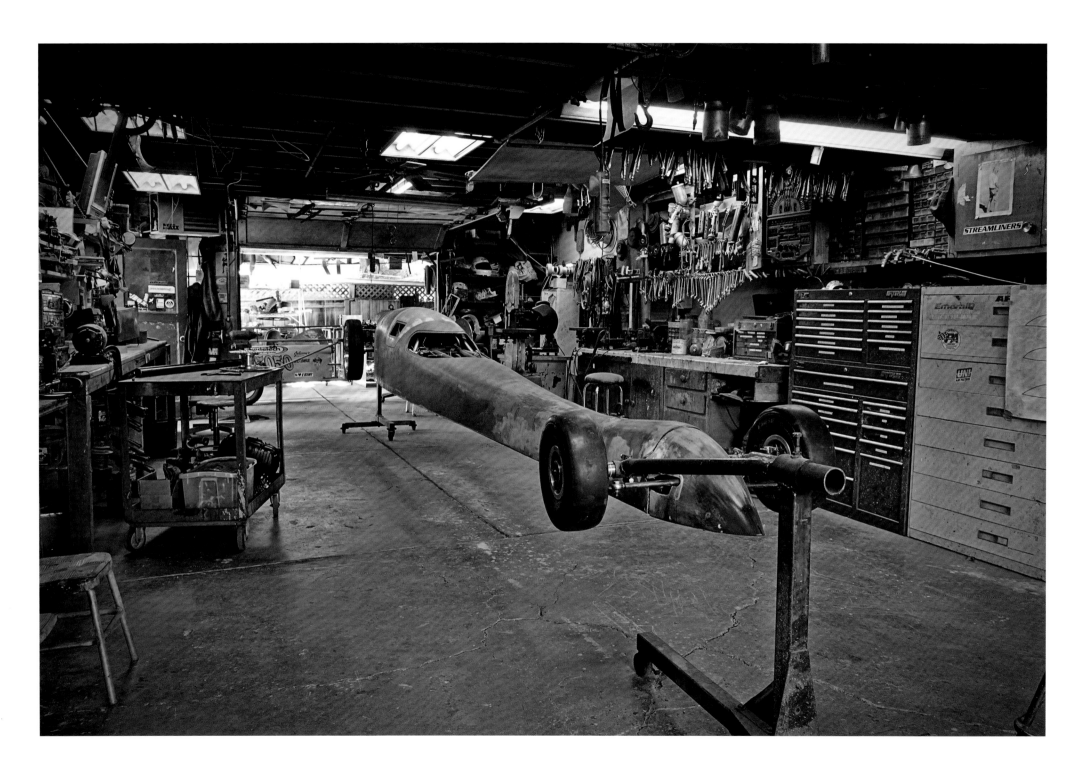

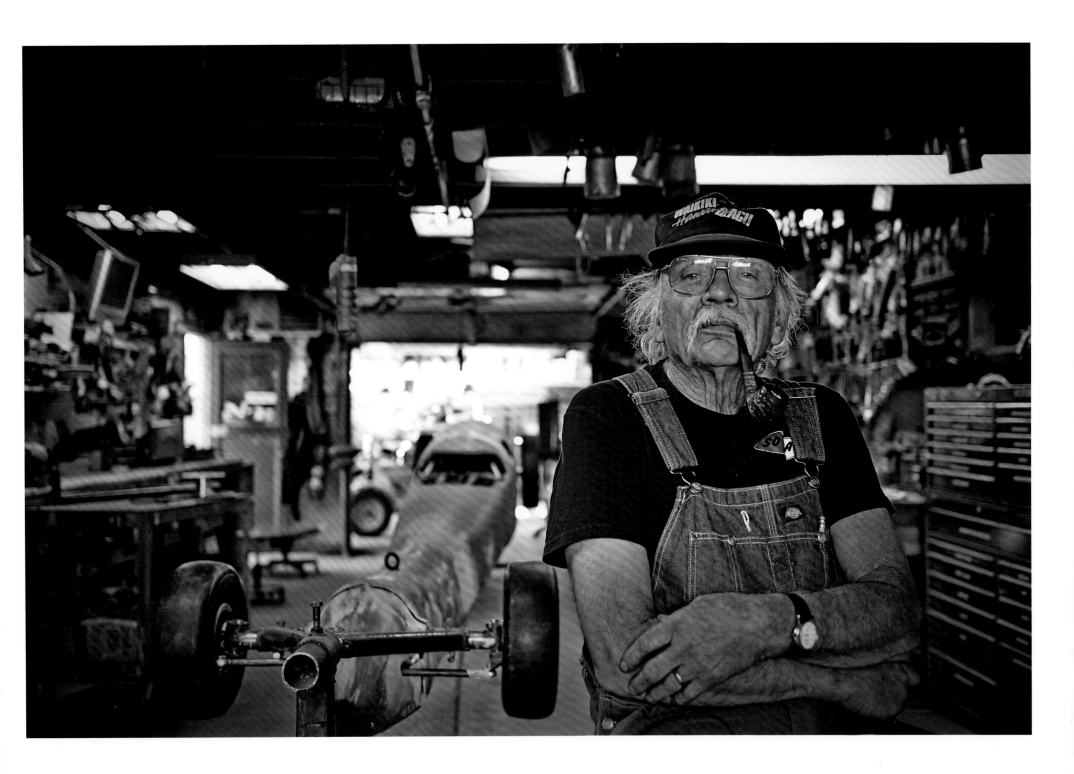

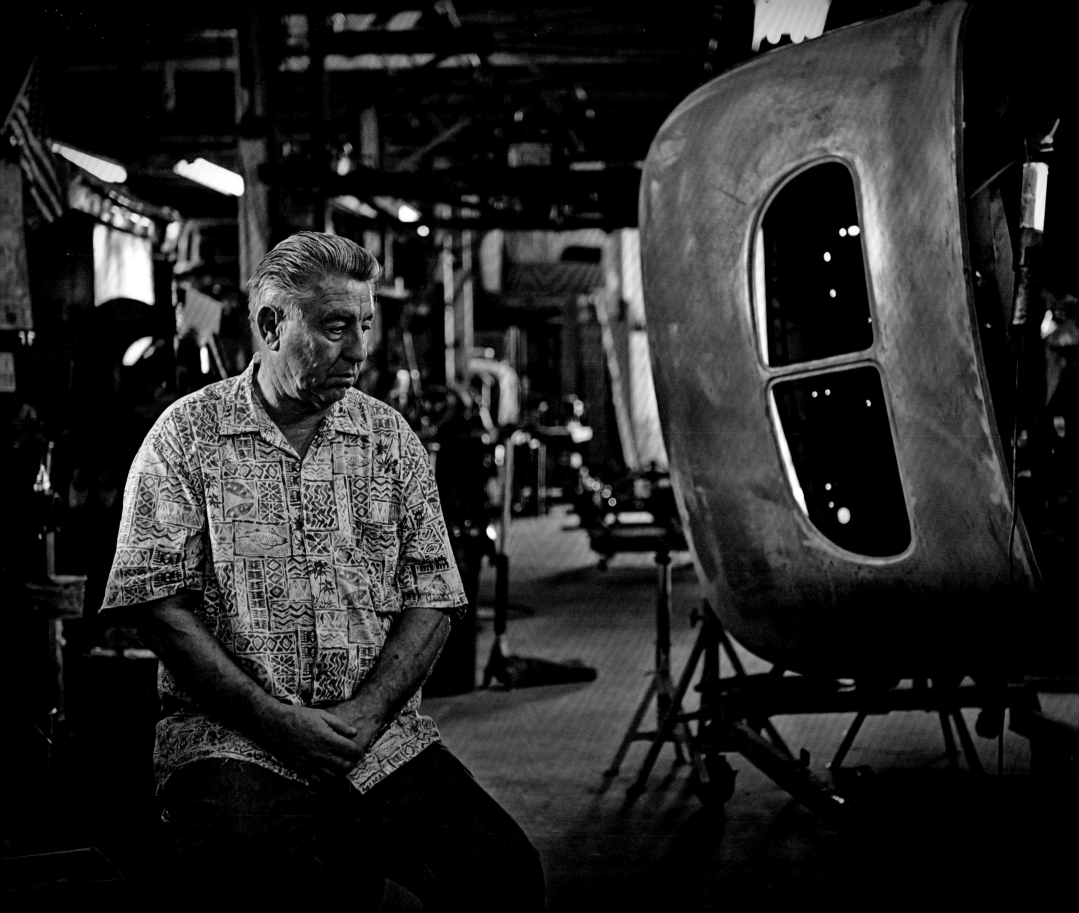

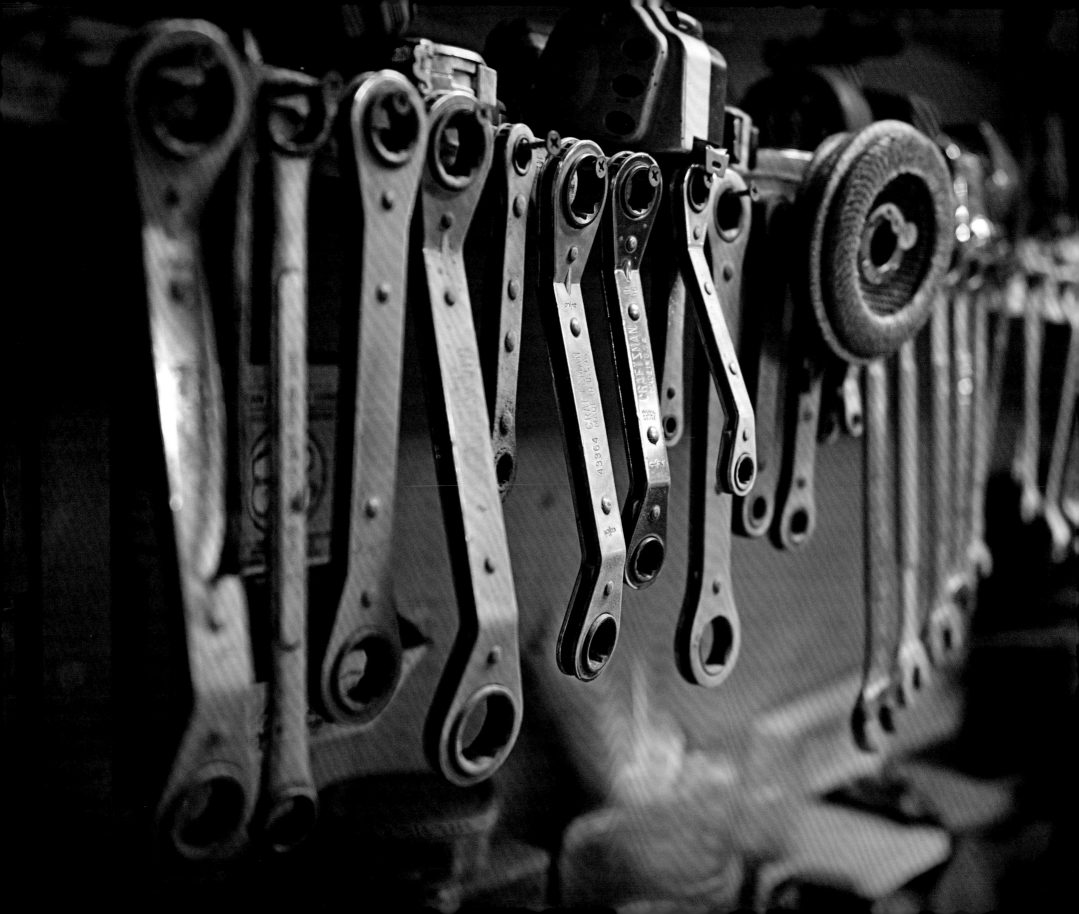

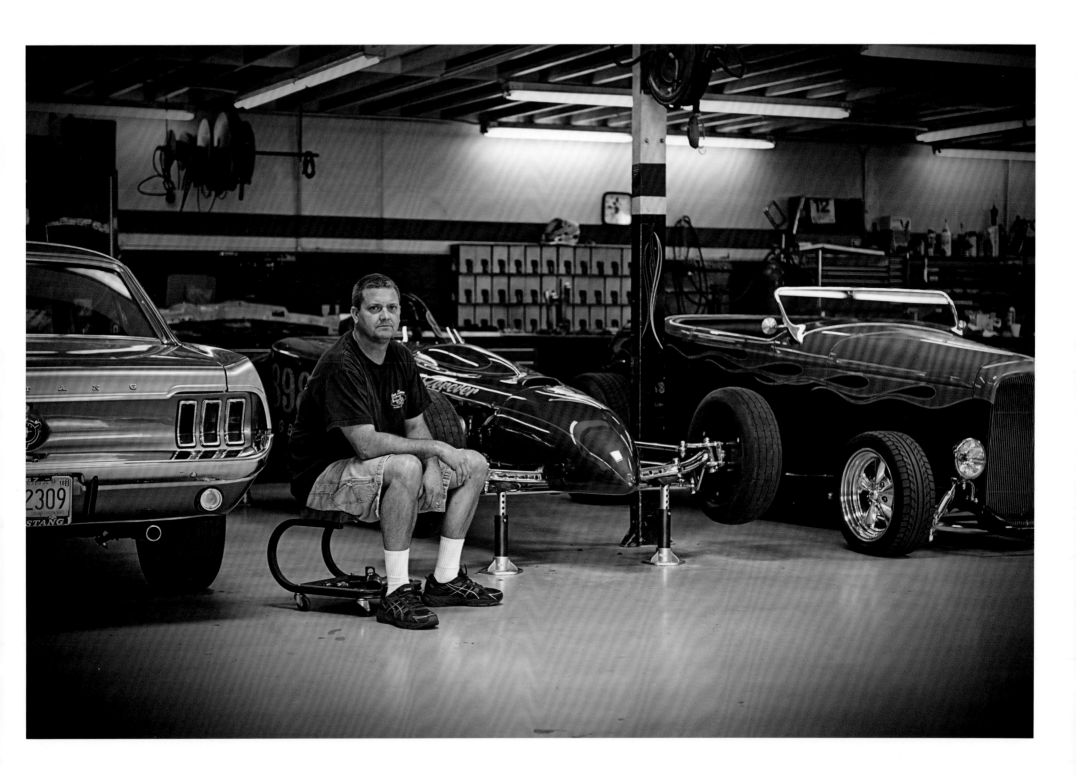

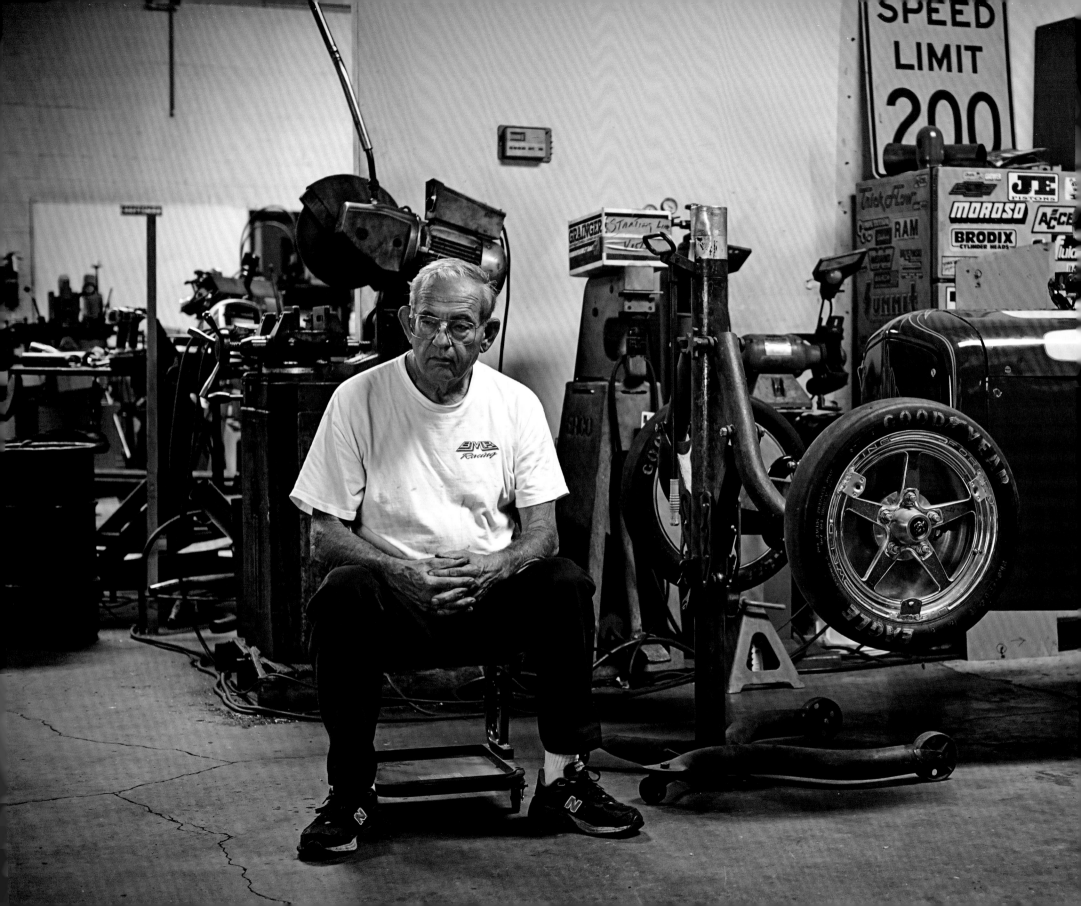

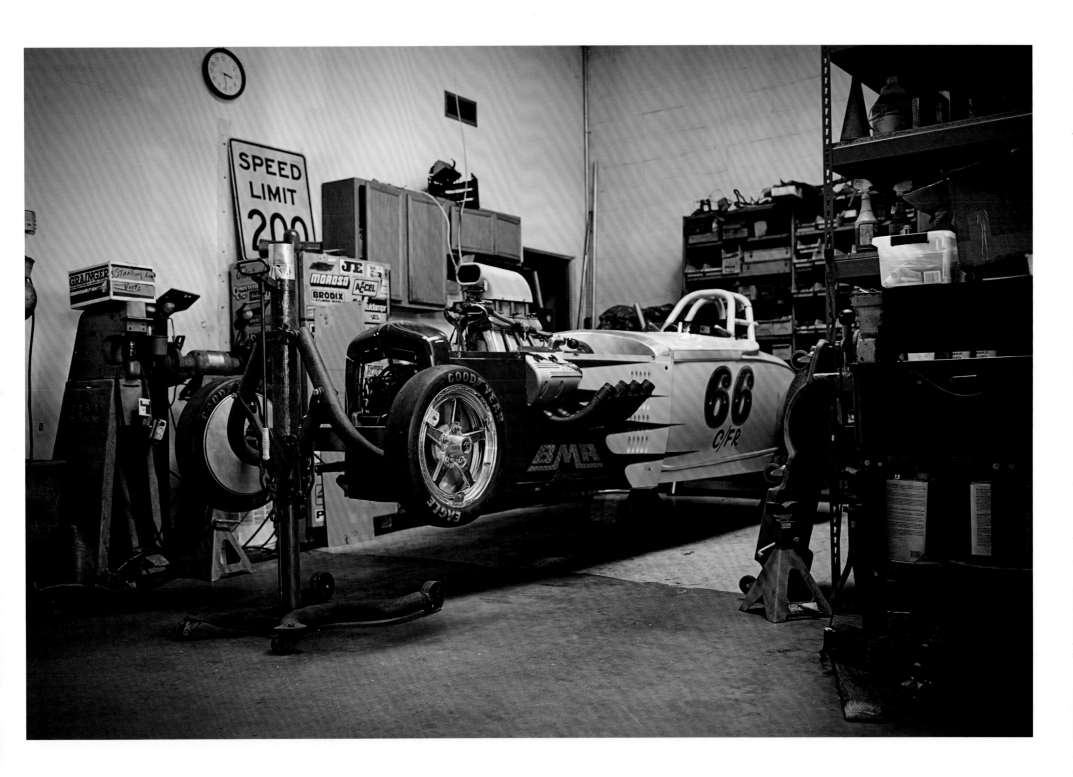

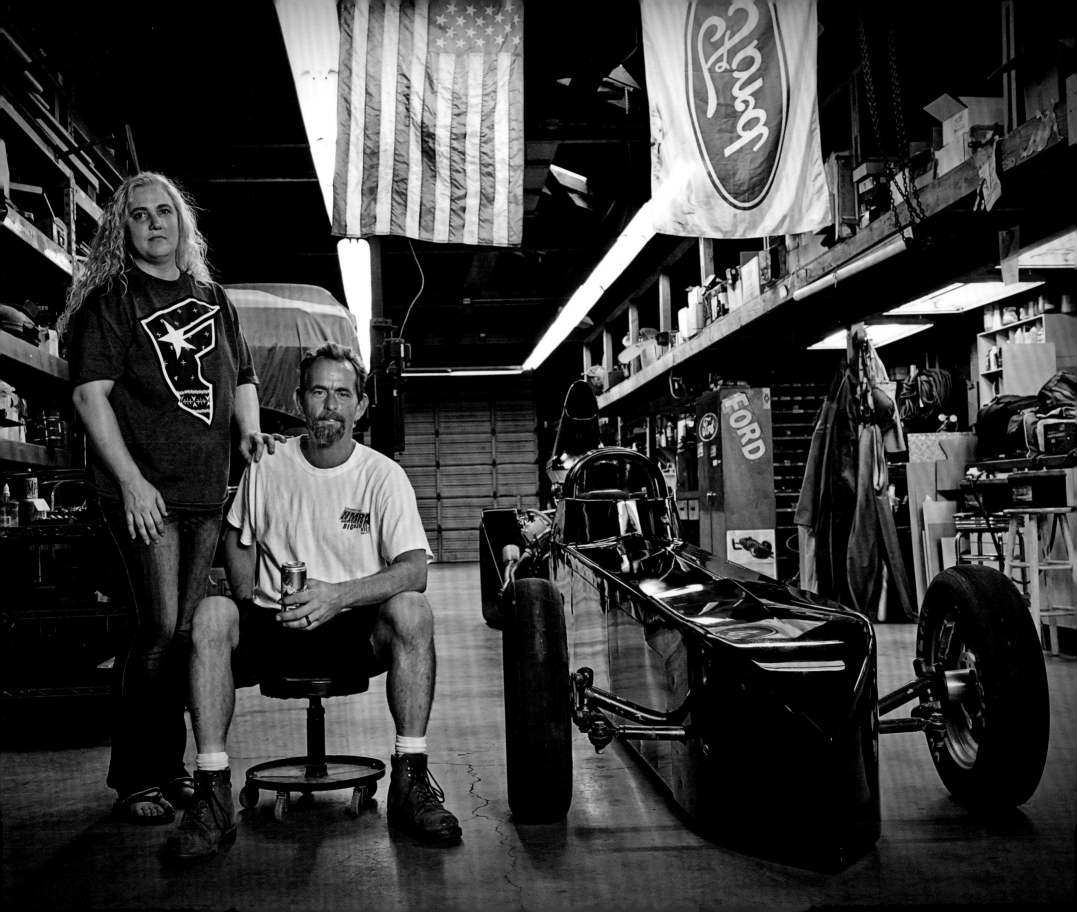

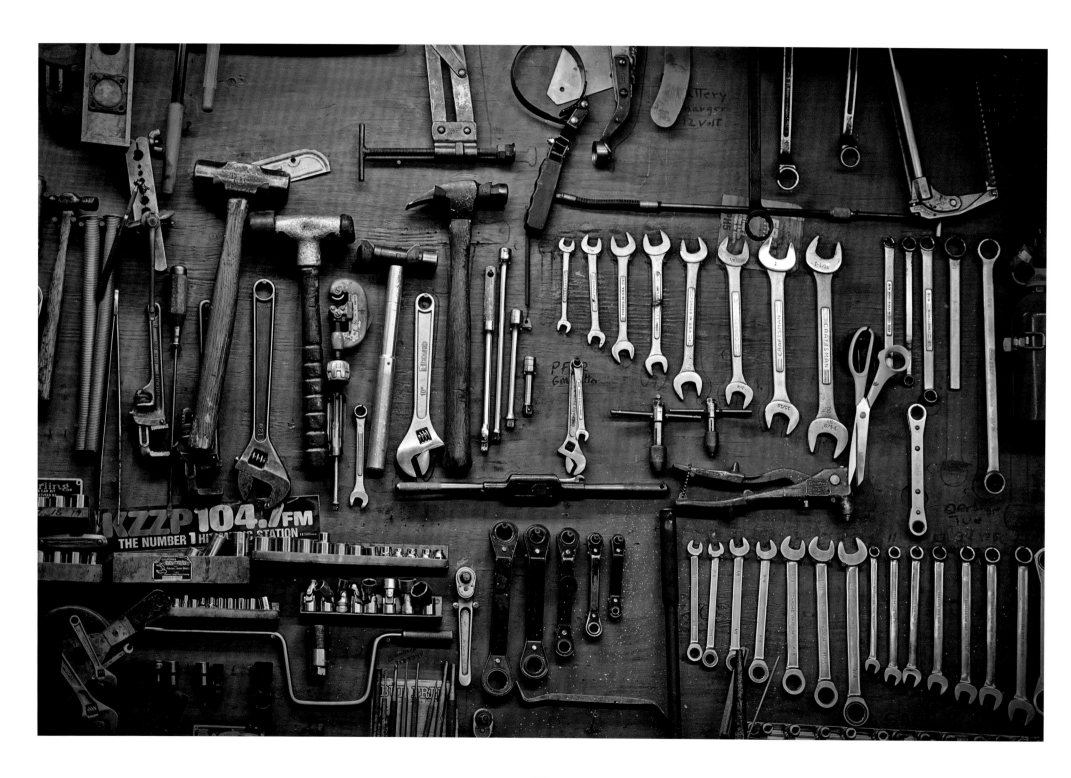

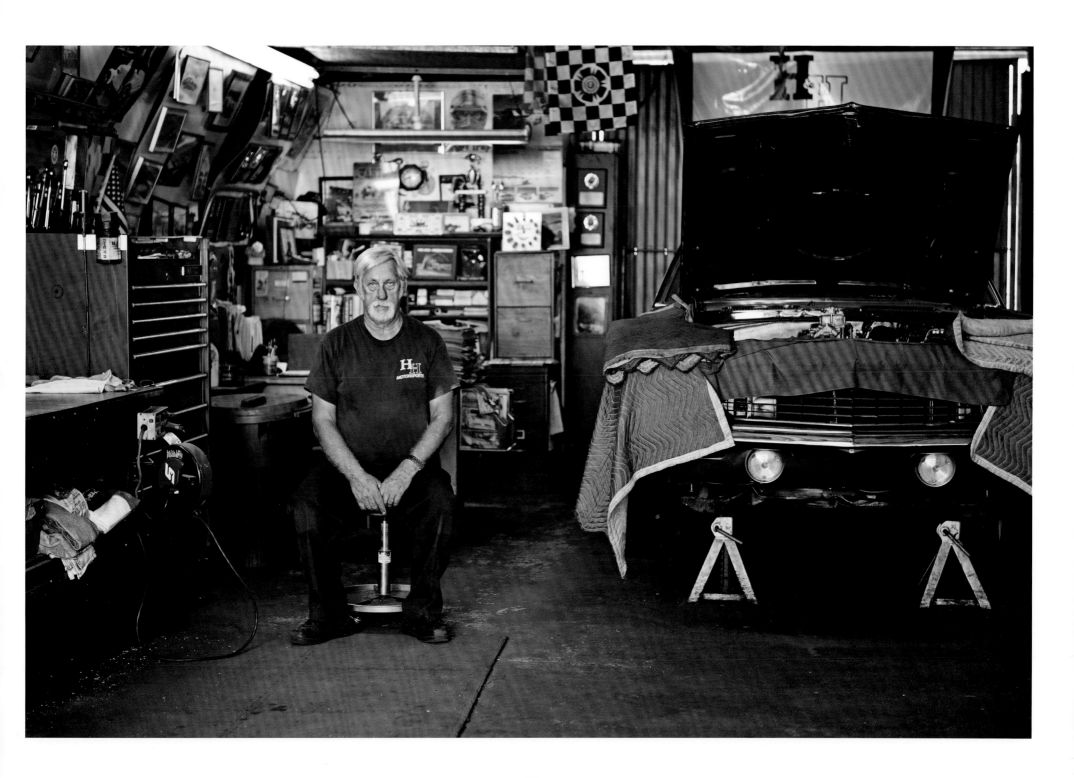

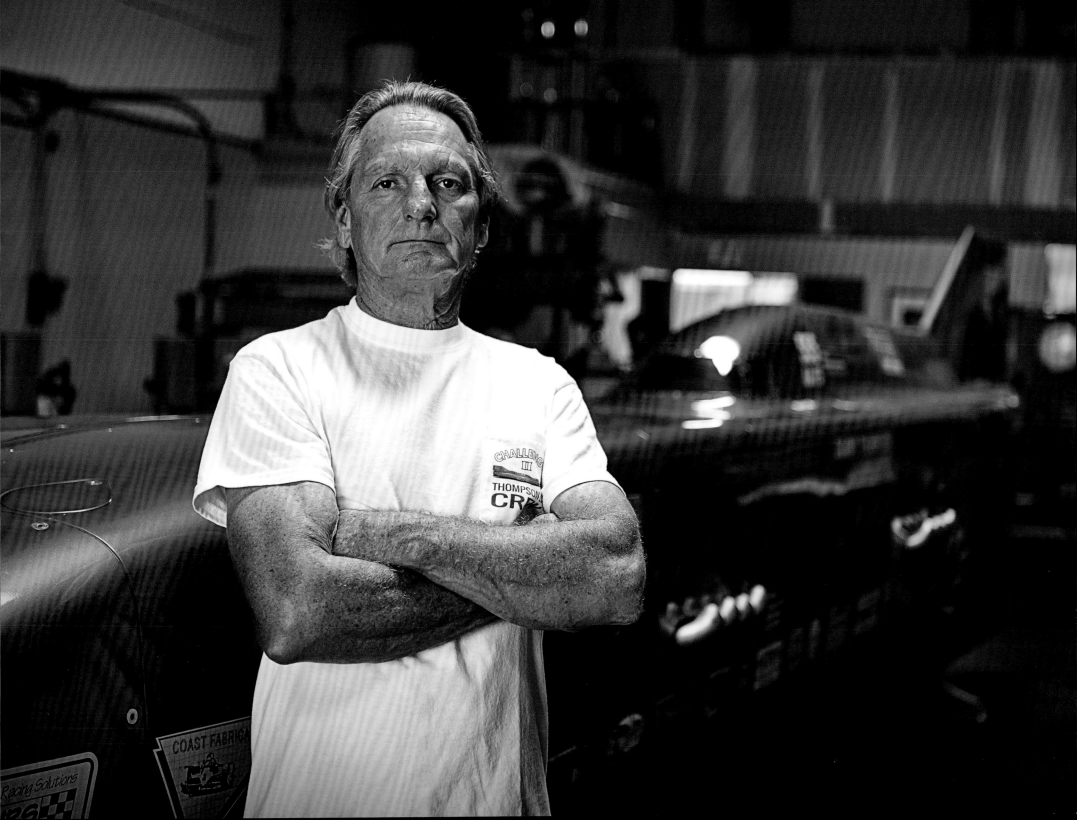

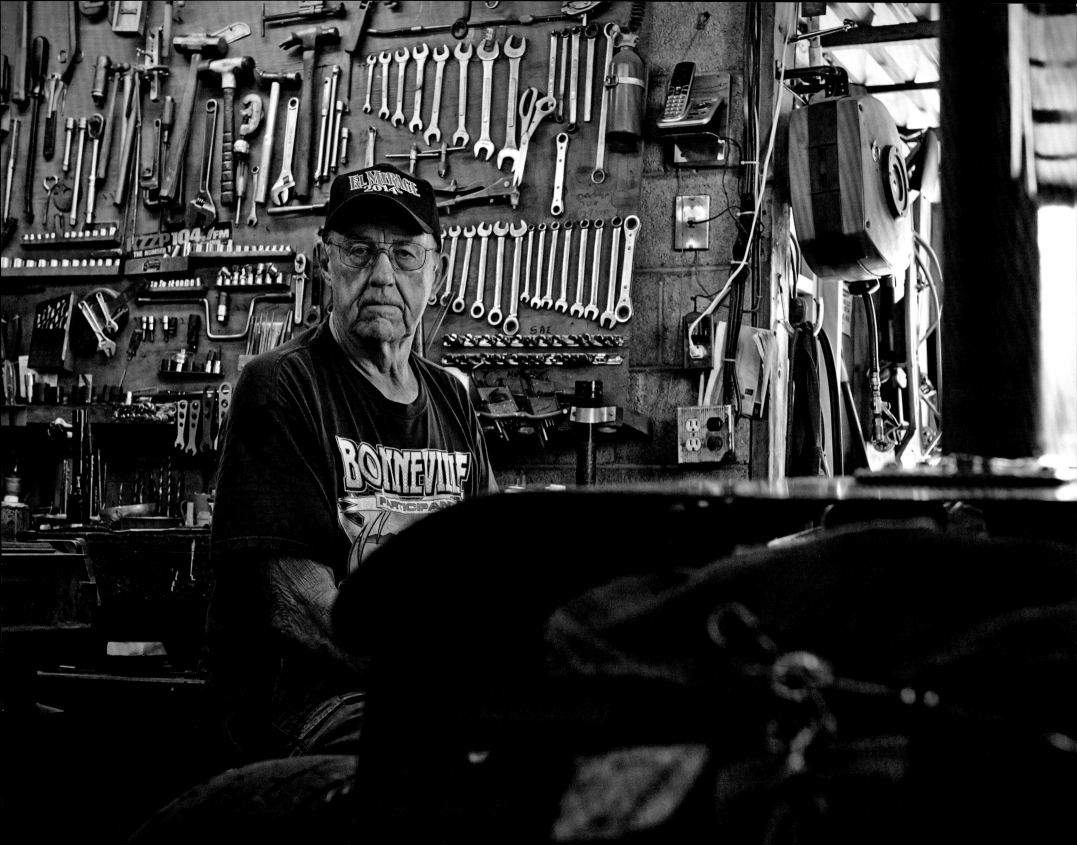

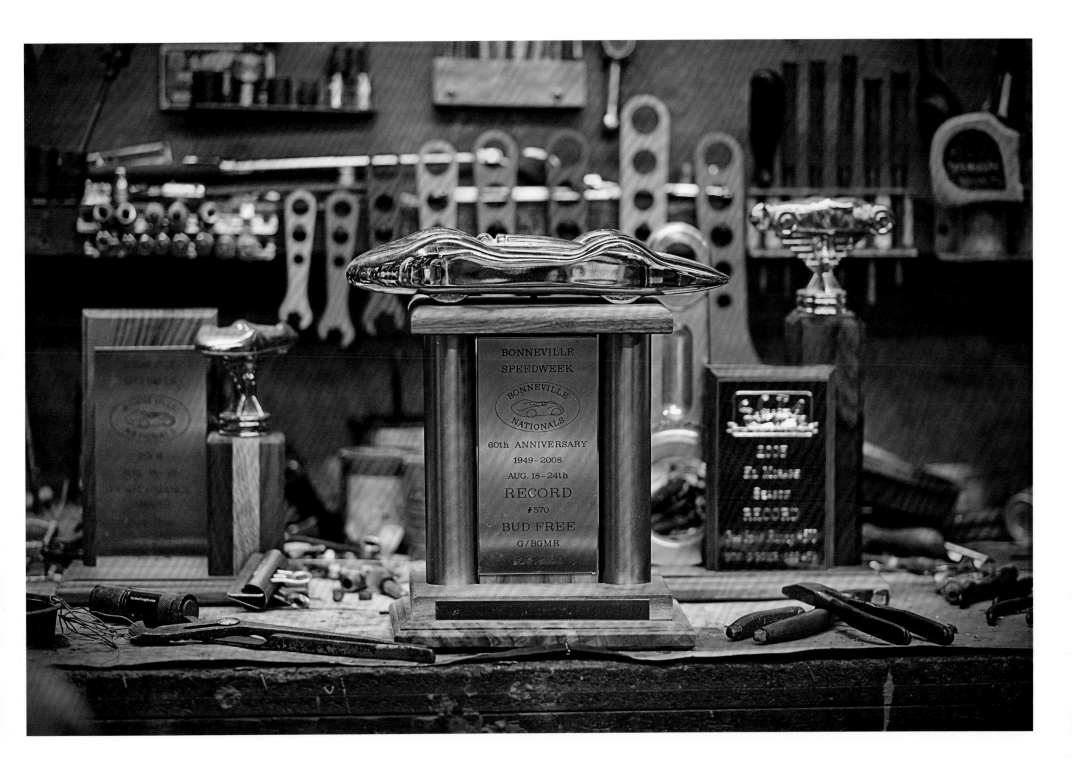

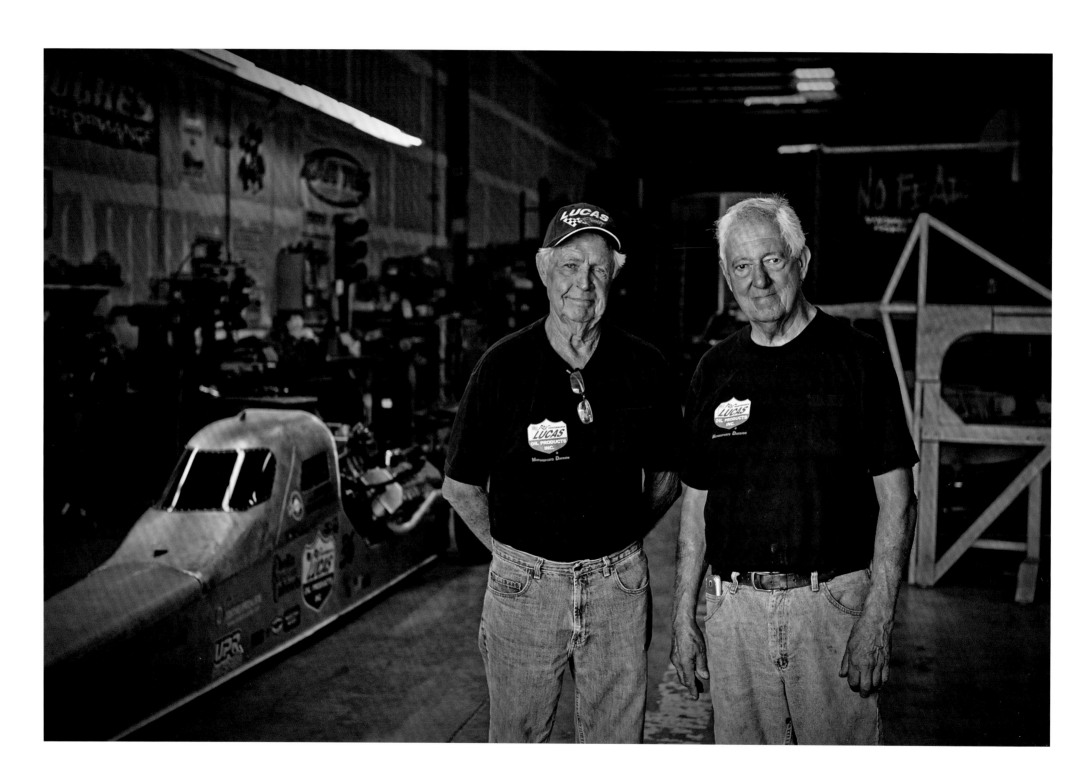

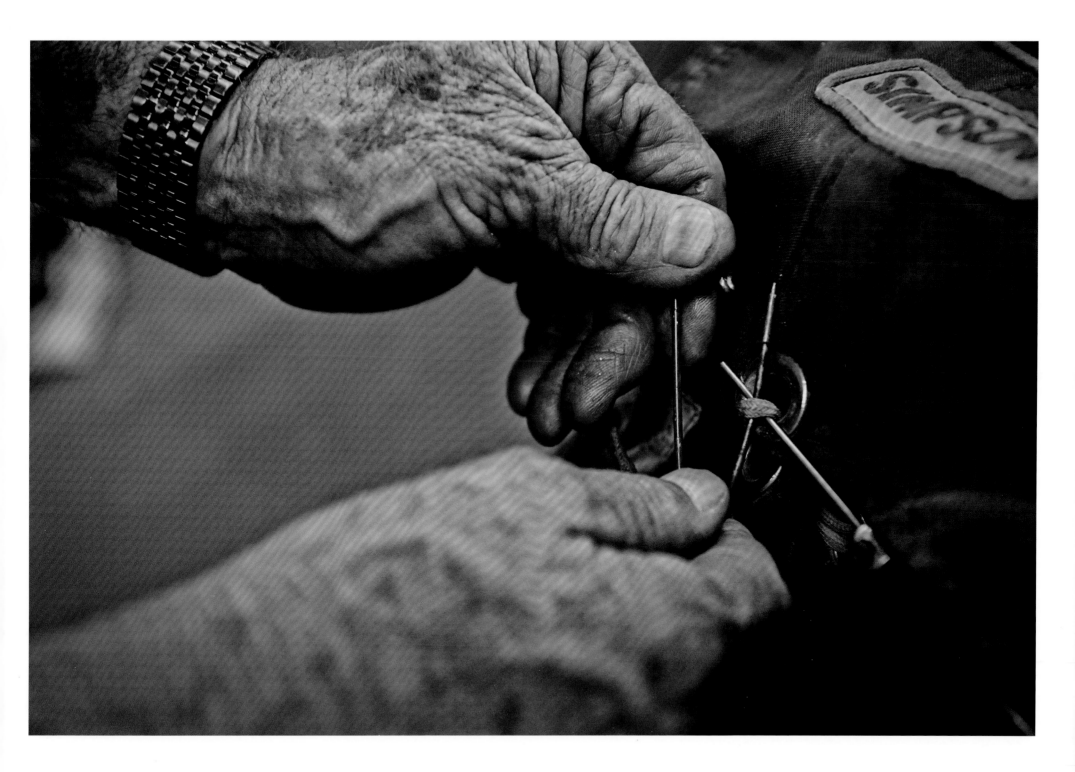

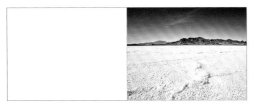

P. 1, #1: The Bonneville Salt Flats cover just over 46 square miles with a crust of 90% common table salt that can range from less than an inch at the edge to over 5 feet in places. The surface changes from year to year depending on the weather and during the winter a shallow lake covers most of the surface. Due to active potash mining the salt is slowly receding.

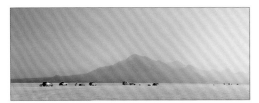

P. 4–5, #2: The early morning is a magic time on the salt when the air is relatively cool and racers begin to line up for the day's runs.

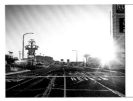

P. 8, #3: The state border between Utah and Nevada separates Wendover into East and West. The Nevada side is comparatively well off with plush hotels, casinos, and newer housing. Gambling, strippers, and hard alcohol are readily available 24 hours a day in West Wendover. Note the casino sign advertising a male stripper night for "deer widows": wives who stay at home while their husbands go off hunting.

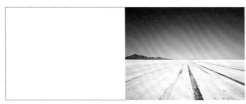

P. 11, #4: Looking down the course from the starting line you can see "Floating Island" about 15 miles away. The track is defined by fluorescent orange flags on either side as mile markers and is painted with a black line down the center to help drivers stay on course at high speed. You don't want to lose track of things at 300+ mph (482+ kmh).

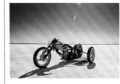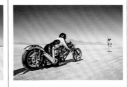

P. 12, #5: This angle truly shows how the sidecar class comes up with a lot of unusual variations. Len Jones's was built by Willie Buchta and is powered by a single-cylinder Buell based engine. This bike set a record in the 500cc class in 2010 that still stands and has hit a top speed of 134.635 mph (216.67 kmh) at El Mirage.

P. 13, #6: Len Jones is ready to go on the starting line aboard motorcycle side car #349.

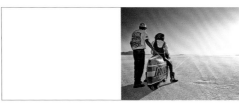

P. 15, #7: Ralph Hudson with his friend and crew chief, Ted Silver, at the starting line.

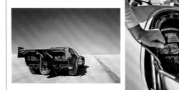

P. 16, #8: This burly 1985 Ferrari 288 GTO is the "Cavallo Volante," world's fastest Ferrari with a 2010 AA/BFMS record of 275.401 mph (443.21 kmh). Owner Steve Trafton teamed up with tuner P4 by Norwood to plant a 540 inch Dart big block with twin turbos into the midships. Somewhere in the neighborhood of 1000 horsepower to the wheels and load of lead in the nose to keep it on the ground got the record.

P. 17, #9: Starting line preparations for Jim True in his I/GS 'liner. The line is the final checklist of all the lists that the crew has been through getting the car and driver ready. At the line, a last gulp of water, some shade, and experienced hands buckling you in are essential.

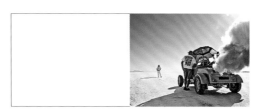

P. 19, #10: No, the Mallo Racing, '28 Ford, E class blown street roadster is not on fire. It is merely waiting for the course to clear to make its run while the Cummins diesel chuffs away. The crew member with the umbrella is absolutely indispensable in this kind of heat.

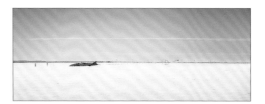

P. 20–21, #11: The Poteet and Main Speed Demon has broken records, engines, and the car itself. The

one thing unbroken is George and his team's will to best their world's fastest piston-driven two-way average record of 437.183 mph (703.58 kmh). The top speed? 451.933 mph (727.32 kmh). This car has put George over 400mph over 30 times. The capabilities of the new Speed Demon are sure to astound. Can 500 mph (804.67 kmh) be far away?

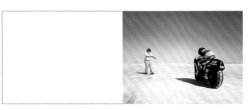

P. 23, #12: Mike Garcia gets the go-ahead at the start line. Mike is relatively new to the flats but wasted no time and made it into the 200 mph Club in 2012.

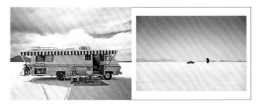

P. 24, #13: This is the true "Taj Mahal" of spectating on the flats: massive shade, a cool carpet for salt-weary feet, and cold beer.

P. 25, #14: George Roseland with the chute out on his '41 Studebaker, #1941, chasing a 265 mph (426.48 kmh) record. This view is from the spectator viewing area about a quarter mile off the track for safety. Binoculars are pretty handy but the sounds are every bit as thrilling as the view.

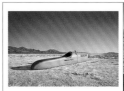

P. 26, #15: Jim True's 'liner at the end of the course.

P. 27, #16: Jim True and his wife Mary True are both members of the 200 mph Club. Here is Jim at the end of a run in their 1000cc displacement gas powered streamliner (I/GS). Judging by the rough salt just behind him it was a fast run that used up the entire course. The car set the record for I/GS in 2012 at 262.188 mph (421.95 kmh) with a Kawasaki 1000cc motorcycle engine for power.

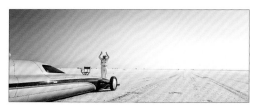

P. 28–29, #17: "No Nitro" Hammond lakester gets the "go" at the start line. 300 plus is the norm for this car. In AA format the power comes from a 632ci big block Chevy by Dart, Reher-Morrison heads, built by Dave Ebbert of DNE Motorsports.

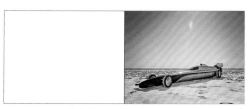

P. 31, #18: This lakester is the latest iteration of Seth Hammond's record breakers. The previous lakester made Seth's wife Tanis the first woman over 300 mph and the new one here has taken Tanis to a new AA Fuel Lakester record of 323.473 mph (520.58 kmh). The rest of the family gets a shot too; father Seth Hammond and daughter Tegan are 300 mph Club members and so is the son, Channing. Channing Hammond designed the car, the body was built by the Gaffoglios at Metalcrafters, the chassis was done in-house.

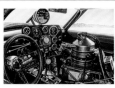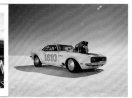

P. 32, #19: More spacious than a streamliner but not quite a Cadillac, the Sundowner '68 Corvette interior includes only what is necessary to get the job done and still leave room for the driver. During a run, about the only things the driver has time to pay attention to are the course and the tachometer.

P. 33, #20: The man behind this perfectly sane insanity is Anthony Taomorina, whose 1968 Chevy Camaro comes to life straight out of a Big Daddy Roth drawing out onto the salt and runs as fast as 218 mph (350.84 kmh) with a 302 ci. blown Chevy motor. Stick that in your Z-28!

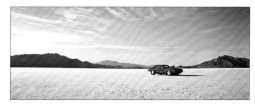

P. 34–35, #21: Owner Jim Snyder and driver Phil Grisotti have been campaigning this classic 1970 Barracuda with 426 Hemi power since 2007. The "Red Hat" finally came when Phil tromped the B/CBGC 'Cuda to a 226.243 mph (364.10 kmh) two-way average.

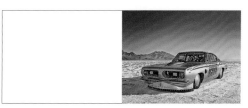

P. 37, #22: Driver Denton Hollifield got himself into the 200 mph Club in 2012 with a two-way average of 249.788 mph (401.99 kmh) in "The Flying Fish," a 1968 Plymouth Barracuda. This Mopar is owned by Paul Ogden and features 528 inches of blown Hemi power on gas.

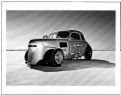

P. 38, #23: The spirit of Bonneville is not only winning, but is also the thrill of building your own machine and running it flat out. Chandler and Keith Young, The Young brothers in their 70s, run their XO Vintage Gas coupe shy of the class record for the sheer joy of it. An old 302ci "Jimmy" (GMC) inline six gets them up around 150 on the 160 record.

P. 39, #24: John Oakes initially started coming to Bonneville as a spectator and recently made his dreams come true when he joined up as a crew member on the Rockin' Johnny team.

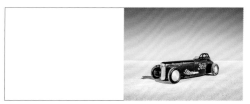

P. 41, #25: This has to be one of the most famous roadsters ever to run on the salt. #369 has held over 20 records and was originally built by long time partners, 200 mph Club members, and SCTA board members Dana Wilson and Mike Waters. Both men have since passed away but the roadster is still racing and is a testament to the fine construction the pair put into it. The "White Goose Bar Team" is campaigning it now.

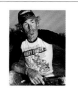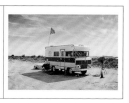

P. 42, #26: Many spectators bring along all sorts of vehicles for off-road use around the flats. Julio here has been getting dusty on a vintage Harley Davidson 125cc trail bike.

P. 43, #27: Not very many people get to camp right out on the salt. This sweet rig is the year round home of TR and Rosie, who come to Bonneville every year as course stewards. TR makes sure the course is safe and is responsible for the extremely important "sweep up" should a race car crash or lose parts on the course.

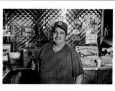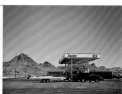

P. 44, #28: Known as Marcello to many a weary traveler and racer, he is Marcello Escovedo, owner of the Salt Flats Cafe at the turnoff for the Bonneville Salt Flats on I-80. Do yourself a favor and stop in for the Escovedo family's honest Mexican fare. Watch for the cafe in location shots from the film, "The World's Fastest Indian".

P. 45, #29: The Vesco family #444 streamliner, AKA "the Little Giant", at the pumps at the Wendover Truckstop. It was originally built by John Vesco in 1957, but only the steering wheel survives of the original. No, it does not run on pump gas but it has put several family members into the 300 mph Club.

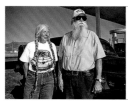 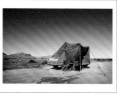

P. 46, #30: Going to Bonneville for Speedweek is a lot like time traveling. This couple is doing it in high style with a homemade trailer built with love from plans in a DIY manual from the '50s.

P. 47, #31: This is a classic "teardrop" trailer made at home from old plans probably found in a 1950s Popular Mechanics magazine. The canvas awning is a nice touch.

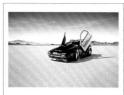 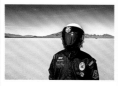

P. 48, #32: It came close to being the world's fastest police car and hit 189 mph before breaking down. The car started out as a 1988 Mazda RX-7 and was transformed by Redondo Beach Police Investigator Royce Branch into a land speed car with Chevy power. As of 2014, the car has been converted for drag racing.

P. 49, #33: This fellow definitely has the cop style down. He won't write you a ticket but he is the driver for Royce Branch. Royce owns the Mazda RX-7 C/GMS "police" car, has been into motor sports since the '60s, and is a big fan of rotary power despite smuggling a Chevy under the hood of the racer.

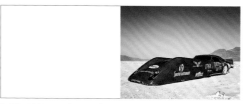

P. 51, #34: Landspeed race cars share bits of their forebears in design and style. Those long fingers shrouding the powered front wheels of Keith Copeland's chopped 1971 Triumph TR-6 pay homage to cars like the Railton Special or Bob Este's old 'liner, but this one has gone far beyond, reaching speeds of 380 mph (611.55 kmh). The official SCTA two-way average of 364.51 mph (586.62 kmh) makes it the fastest in its class and the fastest "Modified Sports" car ever. Power is courtesy of a 362ci twin turbo V-8 making something near 2000 hp. Traction can be troublesome.

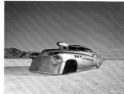 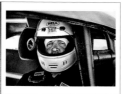

P. 52, #35: Here's a car on every kid's wish list. Like a Pixar sci-fi car on steroids, this 1952 Buick Super Riviera has been chopped, dropped, stretched, and given a brutal futuristic nose job. Owner Jeff Brock claims an unbelievable three-month build time on this XO/GCC record holder that ran 165.735 mph (266.72 kmh) in 2013; the exit speed was over 171 mph (275.20 kmh)! Not bad for an antique inline engine. "Bombshell Betty" is headed for retirement and a new car, "The Evil Twin," should debut in 2015.

P. 53, #36: Jeff Brock at the wheel of the Riviera. Jeff and his wife Star head the creative juggernaut of Rocket Heads Studios. They are not only race car builders but also sculptors and jewelers. Jeff says, "We are instinctually driven to create objects of aesthetic beauty and fast, fine art."

 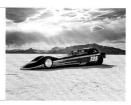

P. 54, #37: George Fields at the end of the course with the old Trackmaster Special Competition Coupe. The new version of the car has already set a C class Blown Fuel Competition Coupe (BFCC) record of 300.022 mph (482.84 kmh) and is every bit as sinister, yet pretty, as this one.

P. 55, #38: This is the old #125 Simca bodied Trackmaster coupe built by George Fields and Dave Casteel. This car still holds records in the A, C, D, and E engine classes of the BFCC category and is the first coupe over 300 mph with a record that still stands for the A/BFCC class at 305.607 mph (491.83 kmh) set in 2001. According to George, "There aren't any words that I know of to express the feelings of going 300 mph in a car you designed and built from scratch. The senses are so focused on every aspect of the ride, where it seems you have become one with the car, and you can feel the smallest thing that doesn't seem quite right. I have felt a tire blister at over 300 mph."

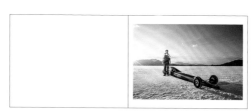

P. 57, #39: Jack Costella and Nebulous Theorem VI, #6060, in the long sun at Bonneville. This car has set and currently holds eight records since 2008.

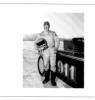 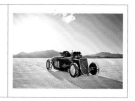

P. 58, #40: Here is Dave Davidson looking like he's out taking in the breeze after another run in his 300 mph (482.80 kmh) A/BFR #911 roadster. Just think about it: 300 mph. No roof. A windshield? You must be joking.

P. 59, #41: This is the world's fastest roadster and the first over 300 mph. Dave Davidson and the Vintage Hot Rod Design and Fabrication crew with engine builder John Beck got Dave into the 300 mph Club with a two-way average of 310.150 mph (499.14 kmh).

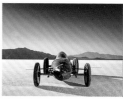 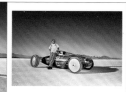

P. 60, #42: This head-on view of the "Old Crow" belly tank shows off classic lines and design. The body is from a WWII-era external fuel tank carried by fighter planes under the fuselage for long range action; hence the name "belly tank." True to form, the car only runs early Ford four-cylinder A or B motors and holds seven records in its class and has topped out at 168mph with a 214ci 1932 Ford "B" 4 cylinder engine built by Max Herman.

P. 61, #43: Bobby Green started out as a hot rodder and became interested in the early days of Southern California dry lakes racing. He says, "once I learned it--the racing--was still happening, I knew I had to try it just like the hot rodeos did in the '30s and '40s." After six years of parts collecting and construction the "Old Crow" number 1952 belly tank lakester is a record-holding reality. Style and substance fully come together in this beautiful race car.

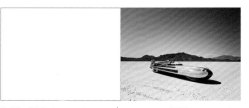

P. 63, #44: Long-time salt veteran #76 was originally built by Terry Nish, run by Team Vesco, and then sold to Ferguson Racing, who runs it today in B/GS. It is an eight-time record holder at Bonneville with another 14 held at El Mirage. The fastest speeds it has achieved so far at Bonneville and El Mirage are 302.462 and 269.147 mph (486.77 and 433.15 kmh), respectively.

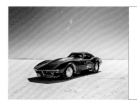

P. 64, #45: The "Sundowner" Corvette is an unlikely success story thanks to the efforts of Duane McKinney, Gail Banks, and Bob Kehoe. Duane bought the convertible '68 off a used car lot in 1975 and promptly began racing it. The body looks swoopy but it's not and a lot of lead is distributed throughout the car to keep it on the ground at over 200 mph. In 1982, this was the world's fastest "doorslammer" at 240.738 mph (387.43 kmh). It was brought out of retirement in 2000 and with John Meyer at the wheel got the D/BGT at 227.78 mph (366.58 kmh). It currently holds the B, C, and D records in its class.

P. 65, #46: Dave McKinney gets a fair amount of time behind the wheel of his dad's old "Sundowner" 'Vette. At Speedweek in 2010 he piloted the car to a 251.838 mph (405.29 kmh) two-way average in B/BGT and broke his dad Duane's record set back in '82.

P. 66, #47: Otto Ryssman has been going fast as long as Art Chrisman has; they both ran over 200 in 1952, a year before the "Two Club" was founded in 1953. Both men are still going and are the oldest living members of the 200 mph Club. Their contributions to Bonneville and motorsports are truly legendary.

P. 67, #48: Athol Graham's ill-fated "City of Salt Lake" streamliner has been lovingly and beautifully restored for display by his son Butch. Athol was an inventor and designer who built the car from scratch in 1959 and tragically died when it wrecked in August of 1960 attempting the 400 mph (643.74 kmh) mark.

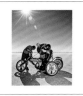

P. 68, #49: Connie Beavers-Nicolaides was one of the fastest ladies at Bonneville. She began racing her 1350cc Suzuki Hyabusa when she was a mere babe at the age of 71. Her fastest time was 227 mph and she had a record in 2008 at 210.6 mph (338.93 kmh) on her Hyabusa. That smile she has in this photo was pretty much a constant with Connie. She married her partner in love and racing, Nick Nicolaides, in 2010 and passed away in June of 2015. Godspeed, Connie.

P. 69, #50: Len Jones's sidecar getting ready to make the run: Fire suit? Check. Fuel? Check? Hotter than Hades in that sun? Check!!

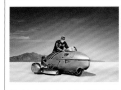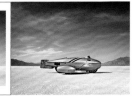

P. 70, #51: The "Tank" looks every bit an art deco wind-up toy but it's actually a record holder in the 500cc motorcycle sidecar class at a mighty 95 mph (152.89 kmh). It once ran as high as 137 mph (220.48 kmh) but was skittish and it was sold to a gentleman in France. Ronnie says, "I started racing on the salt in 2003 with The Silver Rod streamliner. I crewed on that racer for three seasons then I got the fever to ride my own bike. The following year I built my first racing bike and set my first record and the year after that the bike set a world record. In all, I was lucky enough to set six records in my short racing career."

P. 71, #52: "The Tank"

P. 72 – 73, #53: It might seem like a mirage but there really is a candy shop on the salt. Don't go looking for it in the middle of winter, though.

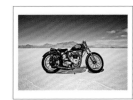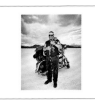

P. 74, #54: Look out "rockers," this is not an ordinary cafe racer. "Four Aces," owned by Wes White, worked and ridden by Dave Frost. This '51 Triumph pushes its 500cc twin up to 104 mph (167.37 kmh) on a 110 record in M/VF.

P. 75, #55: This spectator decided to bring his iguana to the flats on the back of his Harley. He might have been outdone by the guy who brought a camel one year, though the camel did not arrive via Harley Davidson.

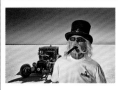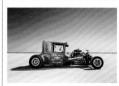

P. 76, #56: Bob is a quasi-legendary character on the salt by now. He arrives every year as a spectator and self professed "speed historian." His killer-kooky, ratted out '27 T and colorful look are familiar sights at the bend of the road.

P. 77, #57: Bob's "Billy Bob's Auto Electric" hot rod Ford Model T is an early example of what some would call a "rat rod" today. No gloss but lots of road tripping to the tune of 36,000 miles in the last 6 years.

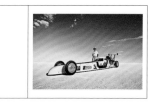

P. 79, #58: "Fast Freddy's" #44, "DFM Racing" lakester follows a rear engine dragster format but is designed for top-end speed over outright acceleration. Freddy and his crew have been a team since 1990 and built the car from scratch themselves. The car has held several records at Bonneville including AA blown fuel at 329.562 mph (530.38 kmh), A blown fuel at 366.586 mph (589.96 kmh), and B blown fuel at 360.077 mph (579.49 kmh). The numbers may seem ironic with the biggest AA engine posting the slowest time but that only shows how capricious Bonneville conditions can be for tuning.

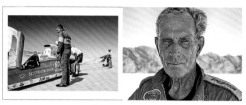

P. 80, #59: Don Biglow and his beautiful Dauernheim/Biglow lakester have held many records at Bonneville since Don began racing back in 1996. With three world records that have since been broken, the crew is back at it with a new body posting speeds up to 322.227 mph (518.57 kmh). Here they are quickly packing up at the end of a run to get back in line.

P. 81, #60: Don Biglow

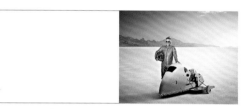

P. 83, #61: This is Wally Kohler's distinctive-looking fiberglass bodied Suzuki Katana framed sidecar with a stock Kawasaki 636 motor. The distinctive split in the body work keeps this bike out of the streamliner class. It holds the current SCTA sidecar gas record at 169.5 mph (272.78 kmh), and once held the fuel record at 167.2 mph (269.08 kmh) back in 2009.

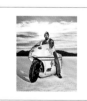 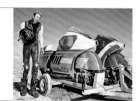

P. 84, #62: A stock 2008 Suzuki GSXR 1000 is a fast bike but not nearly as fast as Jim Hoogerhyde's record holder. This bike is the world's fastest naturally aspirated motorcycle at El Mirage and was completed in just under a year with help from Ted Silver, Ralph Hudson, and Jerry Piazza.

Jim got himself into the "Two Club" on this bike and as of 2010 his two-way average record is 223.705 mph (360.02 kmh)… it looks like the SFMC has a record to be proud of in more ways than one.

P. 85, #63: Record holder Ralph Hudson runs Suzuki GSX-R's from 600cc to 1000cc. The best speed achieved at Bonneville was 242.481 mph (390.24 kmh) with a normally aspirated, partially streamlined, 1000cc GSX-R. It's got a turbo on it now and and is ready to make passes on the salt.

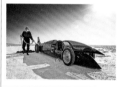 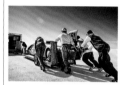

P. 86, #64: Donnie Hicks of Orangevale, CA, after a run in his Toyota powered F/BGL. Note the quick release steering wheel on the ground next to the lakester.

P. 87, #65: After a week of record attempts the Hicks team rolls the lakester onto the tailer for the trip home. They might be going home with no record this time but every run yields more knowledge and hopefully gets you closer and closer until the day comes when it all lines up just right.

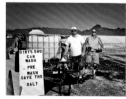

P. 88, #66: Depending on the moisture content of the salt, your car can pick up a few extra pounds of instant corrosion. These two are stationed at the end of the road to blast it off before you return to civilization. It's a good idea to leave the salt where it came from to help replenish the flats.

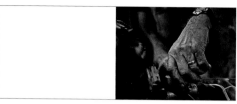

P. 91, #67: A weathered hand attests to the expression "hand made." Most Bonneville cars are completely hand-made, most often by groups of friends and family.

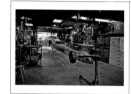 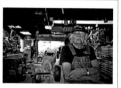

P. 92, #68: Jack Costella's backyard shop in San Jose, CA where "imagination and innovation" keep Jack busy. His shop reflects the desire to "participate in an activity that recognizes and awards creativity and innovation." With over 105 records to date, Jack and the Nebulous Theorem Team have clearly put this shop and their talents to good use.

P. 93, #69: Jack Costella, racer, philosopher, and designer, has built 11 Land Speed Racing vehicles since first arriving on the scene in 1969. His unorthodox designs have challenged the rules, broken records, and caused many an onlooker to scratch their heads in wonder. At the age of 80 he shows no signs of stopping and holds 15 records himself as an owner/driver; he's in the Bonneville Hall of Fame, the Bonneville 200 mph Club, Bonneville 300 mph Club, El Mirage 200 mph Club, and the Muroc 200 mph Club. Jack credits his many drivers and partners and his wife Keiko for all the help and inspiration. His motto? "Racing is work, winning is fun!" His advice? "You only have to be smart enough to know that you don't know anything."

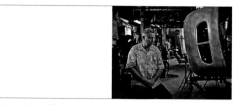

P. 95, #70: Al Teague has been chasing the speed demons on the salt since 1965. Here he his in the shop with a 1940 Ford that he's turning into a streetrod. Now that his record-breaking Spirit of '76 Streamliner (16 SCTA and FIA records!) has been sold, he's decided to put the same Keith Black 480ci Hemi from the 'liner into his street ride. Al is one racer who wholly embodies the DIY work ethic shared by many others at Bonneville and is one of the most respected figures on the salt.

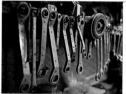

P. 96, #71: Straight and dog-leg ratcheting box wrenches on the wall. These are great for speedy removal in tight quarters.

P. 97, #72: Joe Kugel in the shop with the roadster that he and the family business, Kugel Components, built for Rhett Butler. The #8989 "G" class, blown fuel modified roadster is the 2013 record holder in its class at 215.724 mph (347.17 kmh) with an exit speed of 219 mph (352.45 kmh).

 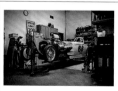

P. 98, #73: Doug Robinson's garage down in Pasadena, CA is deluxe accommodation for any roadster, especially a record setter. The facility

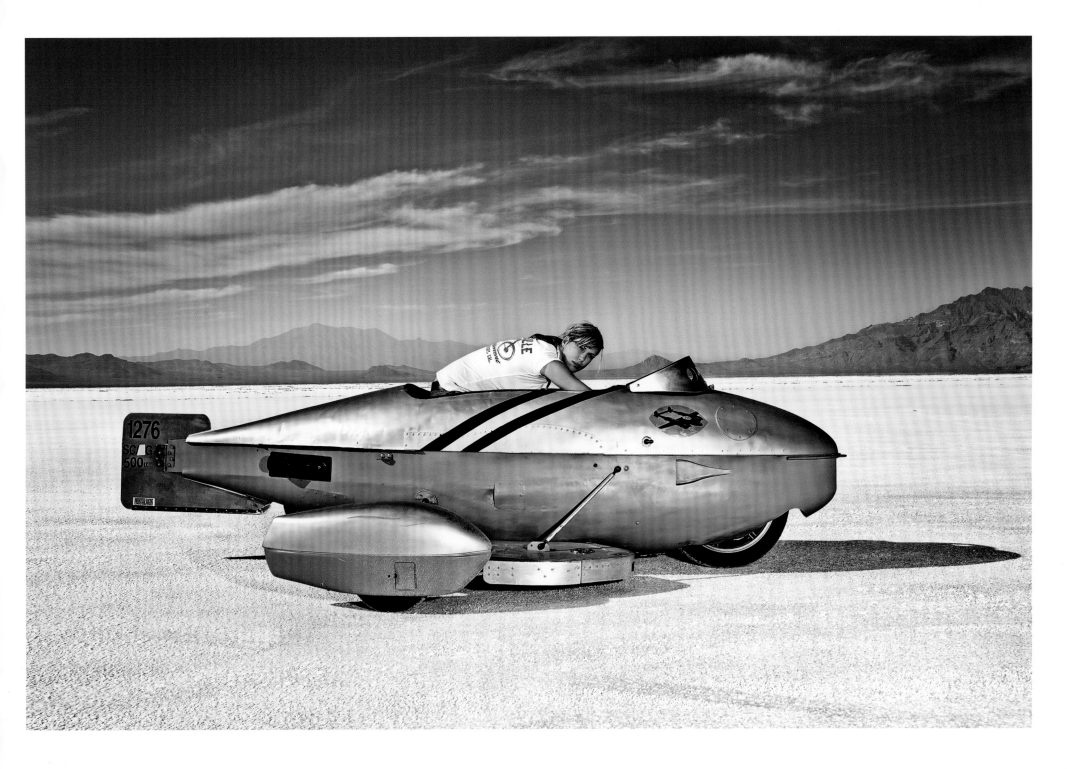

ACKNOWLEDGMENTS: my parents / Jens-Peter Mollenhauer / all my Bonneville friends, especially: Fast Freddy / Kevin Thomson / Jack Costella / Patricia Hewett / Jens-Peter Mollenhauer, Thomas "Pork Pie" Graf / JoAnn and Greg Carlson / Wally Kohler / Al Teague / as well as Diana Wilfer / Christian Wilfer / David Perry / Mary Perry / Anthony Castaneda / Jen Mcmillan / Tom West / Thomas Vogl / Michael & Mirella Hegelbach / Heike Schmidt / Christine Coring / Simone Schillo / Mamé Garnamy / Dirk von Manteuffel / Tony Thacker / David Beitler / Frank Meyer / Miki Bunch / Ralf Kötter / Andrea von Götz / Corinna Connelly / a very big thank you to the gloss Team: Christian Mai / Edwin Immel / Tommy Szewczuk / Pedro Rodriguez / Jenny Grönwald and all the people who are part of this project.